# THE CAT'S PAJAMAS

## 101 OF THE WORLD'S CUTEST CATS

RACHAEL HALE

**Andrews McMeel
Publishing, LLC**

**Kansas City**

in association with PQ Blackwell

There are no ordinary cats.

COLETTE

# INTRODUCTION

My experience of photographing animals over the years has well and truly confirmed my belief about cats—that they are very strong-minded and independent creatures! And that's what makes them so challenging, and rewarding, to photograph. While dogs sit happily in one spot for me, eager to please, cats require much more persuasion —preferably in the form of tasty treats—to comply with my requests. Time spent negotiating with these clever cats is well worth it, however, when I finally get the image I'm after.

Cats are such individuals. I have met a huge variety of breeds and temperaments in my time, and I never cease to be amazed by how different they all are. And what characters! Whatever the breed or background, I've never met a cat that hasn't charmed me or that I wouldn't like to take home. This book contains some of the most popular and adorable breeds I've photographed during my career. While not intended as a complete reference, I hope you will find some of your favorites within.

# Contents

Shorthair

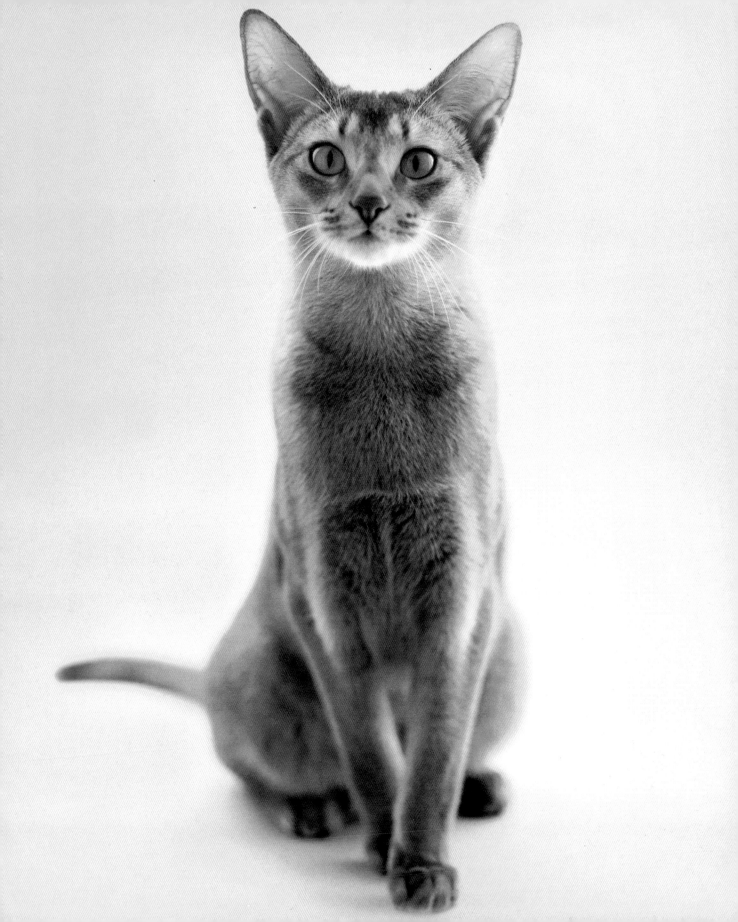

## 1. Abyssinian Ruddy

Standing proud and elegant, the Abyssinian is a striking breed. Named after Ethiopia, formerly Abyssinia, because the first Abyssinian exhibited in England was imported from there, many believe the breed to be a descendant of the ancient Egyptian cats so revered by the pharaohs. Though the exact history remains a mystery, current genetic testing places the source of this beautiful breed to the Indian Ocean coast off Southeast Asia. Considered to be highly intelligent, the Abyssinian is sometimes characterized as being trainable and obedient. It has a great love of human companionship and is extremely loyal, sweet-tempered, and very communicative, appearing to understand its human companion's feelings.

*Appearance: A "Cleopatra" of the cat world, the Abyssinian is beautifully marked: dark eyeliner curving up at the corners highlights the breed's soft-colored eyes, and the striking close-lying ticked coat accentuates the medium-sized, muscular, and slender body.*

*Color: The most common colors are ruddy (also referred to as "usual"), red, blue, and fawn, though the breed can also appear in a sorrel, silver, chocolate, lilac, cream, or tortoiseshell coat.*

## 2. Bengal  Brown Marbled

Handsome and athletic, the Bengal is a cross between the wild Asian Leopard Cat of Southeast Asia and a domestic cat. The first documented attempt of this cross was by an American geneticist in an effort to produce a miniature leopard with a loving temperament. This was in 1963 but it was not until the 1980s, when the breeding program resumed, that the foundation stock of the Bengal we know today was successfully formed. The result is an exotic and strong cat that can appear with wonderful large spots or smaller rosette patterning as well as a marbled pattern on its coat. The Bengal is a social and intelligent animal with an affectionate and loyal temperament toward its owners. Remarkably fond of water, the Bengal occasionally reveals a wild streak but is generally celebrated as being charming, friendly, and playful.

*Appearance: A medium-to-large breed, the Bengal is muscular and strong with a sleek and long body. It has a broad wedge-shaped head with large almond-shaped eyes and distinctive whisker pads. Legs are strong and muscular with large, round feet.*

*Color: The thick, luxuriant coat of the Bengal comes in a variety of colors including brown and black leopard-spotted or marbled markings and snow spotted.*

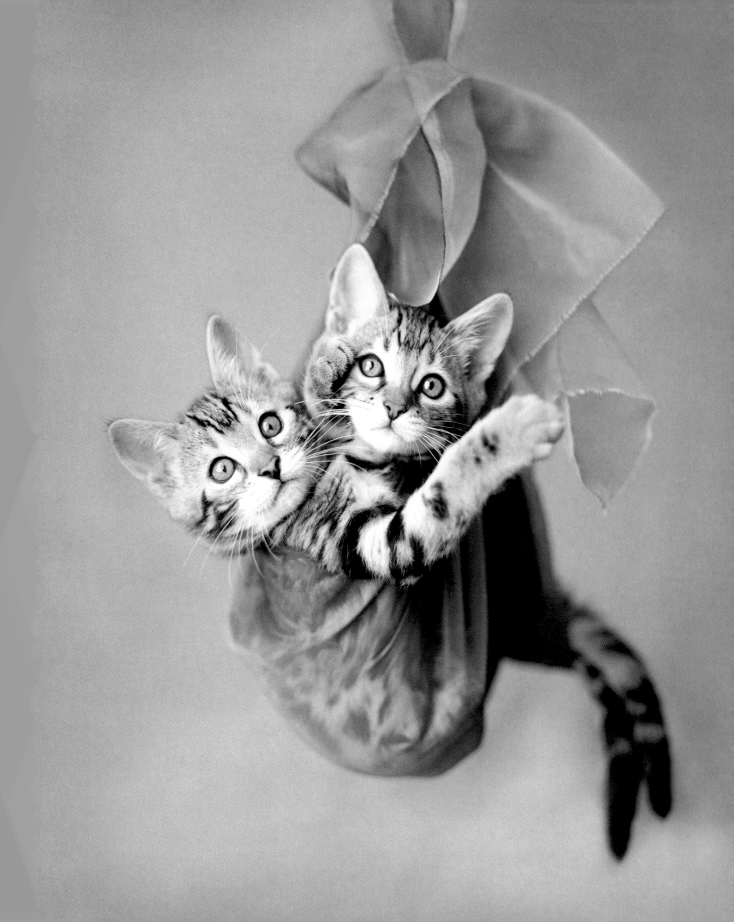

### 3. **Bengal**  Brown Spotted

The unusual and dramatic markings of the Spotted Bengal form horizontally or in a circle, and are also present on the stomach. Extreme contrast between the spots and the ground color is highly prized.

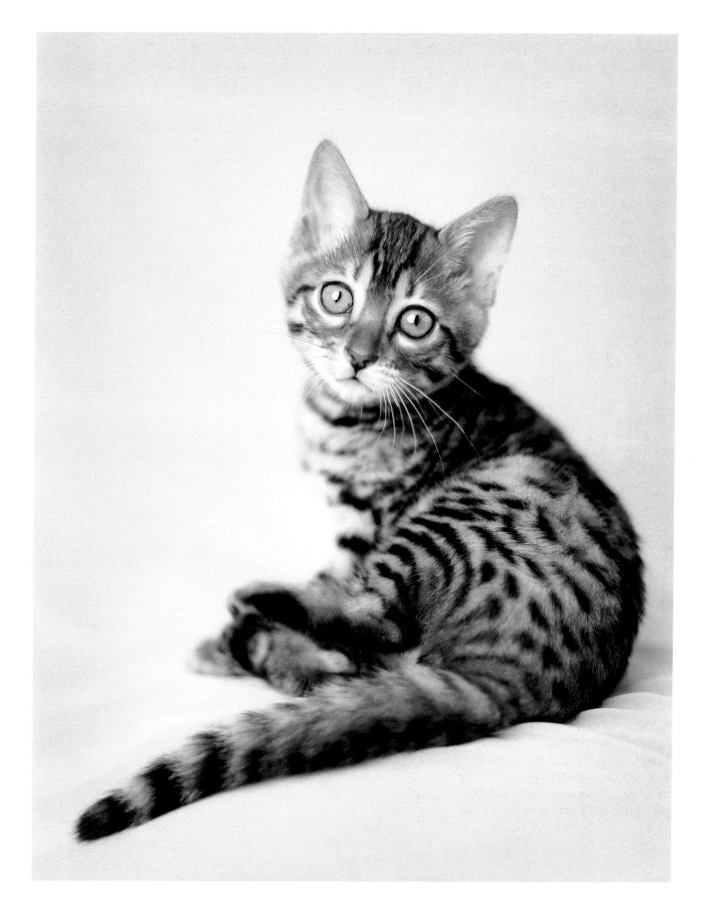

A home without a cat—

and a well-fed, well-petted,

and properly revered cat—

may be a perfect home, perhaps,

but how can it prove title?

MARK TWAIN

**4. Bengal**  Snow Marbled

The beautiful pattern of the marbled Bengal
consists of complex whorls, distinct shapes, and
sharp outlines.

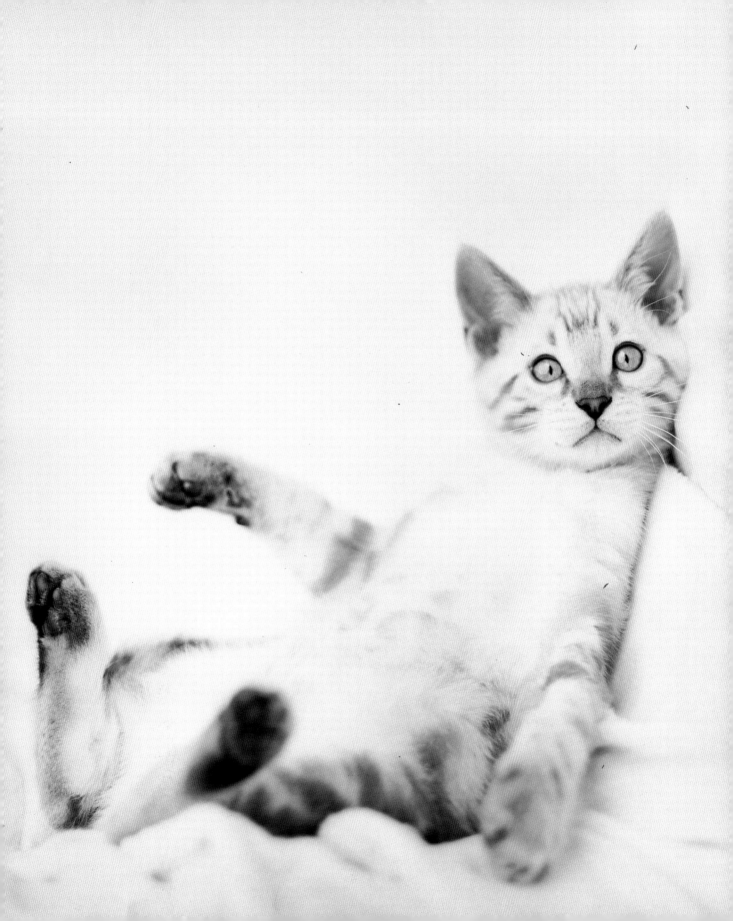

## 5. British Shorthair  Blue

The dignified and charming British Shorthair is an affectionate and gentle breed. It is believed to have arrived in England during Roman times making it by many accounts the oldest English breed. A fine example of a working cat, it was highly valued for its physical strength and hunting prowess. The short coat allowed the cat to be self-sufficient and easy to manage, and as such it was commonly used as working cargo on sailing ships. With the advent of competitive cat shows in the late 1800s, the British Shorthair became a true champion breed with a large following. However, with the introduction of the long-hair breeds, the popularity of the British Shorthair declined and it almost disappeared. In 1901 the Short-Haired Cat Society formed and ensured the breed's survival. Intelligent, independent, and good-natured, the British Shorthair is considered today to be an ideal all-round cat and is widely enjoyed as a family pet.

*Appearance: Large, strong, and muscular, the British Shorthair's size and temperament has seen the cat labeled a "gentle giant." The male of the breed is considerably larger than the female and both appear with short, dense fur.*

*Color: The British Shorthair comes in numerous colors and patterns with the most popular and famous color being blue. The blue coat is perfectly complemented by glowing eyes of copper, orange, or gold.*

## 6. British Shorthair  Lilac

The most contemporary color in the British Shorthair range, the Lilac British Shorthair is a delicate frosty gray with a noticeable pinkish shine.

### 7. British Shorthair  Black

The Black British Shorthair is considered to be one of the oldest of the pedigree breeds and its magical beauty is thanks to a pair of standout eyes of gold, orange, or copper, framed completely by jet black–nose, paws and glossy coat.

## 8. British Shorthair  Blue Point

The colorpoint British Shorthair comes in an array
of point colors, showing clear contrast between
the points and the body color. The Blue Point is a
cool bluish white, shading gradually to white on the
stomach and chest, which contrasts beautifully with
the slate blue points.

## 9. British Shorthair  Black Tipped

The coat of the Black Tipped British Shorthair appears to shimmer. The black color is restricted to the very tips of the hairs and can vary in the degree of tipping while the undercoat is so pale that it appears to be white, although it is actually silver. On the Tipped British Shorthair, the traditional eye color of orange or copper is replaced by green, which is even more striking being framed by black—as if the cat is wearing eyeliner.

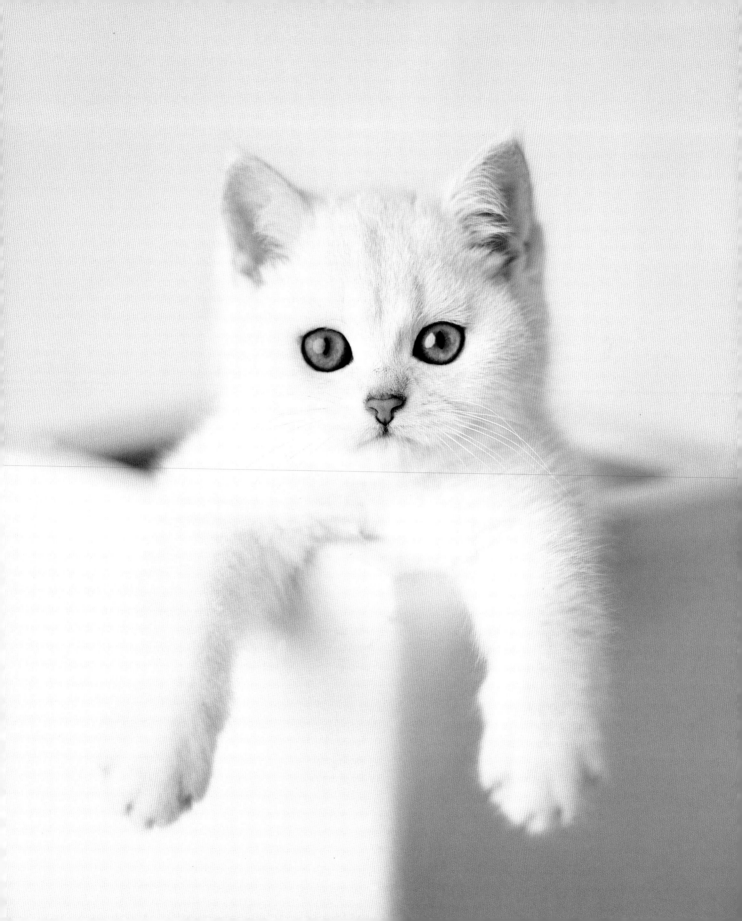

## 10. British Shorthair  Seal Point

Another version of the colorpoint British Shorthair is
the Seal Point. The warm pale-fawn-to-cream tone of
the body coat gradually fades to very pale cream on
the stomach and chest and is vividly highlighted by
the deep seal brown of the points.

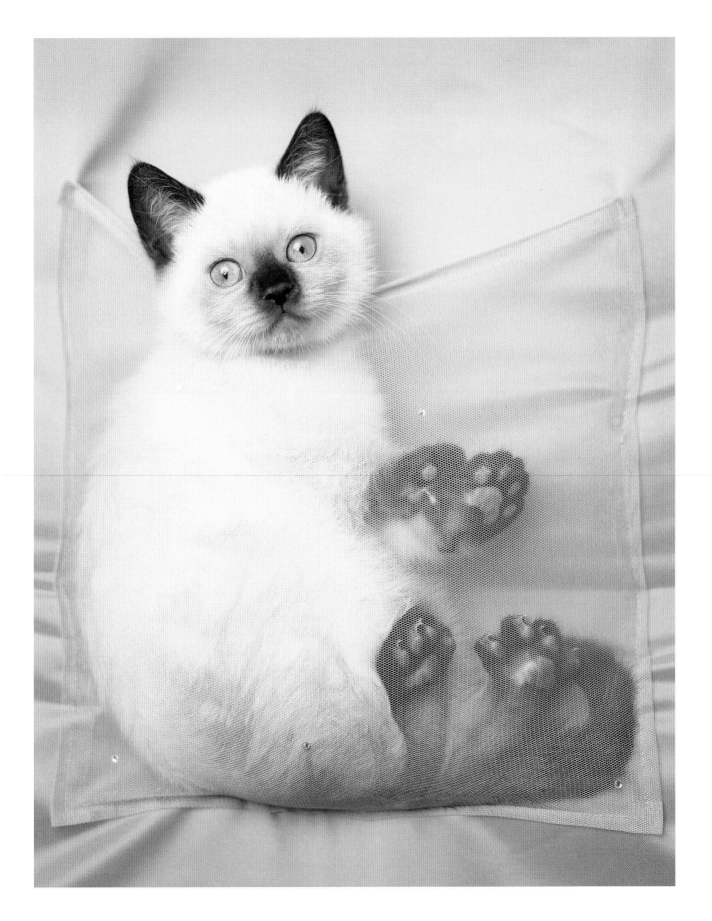

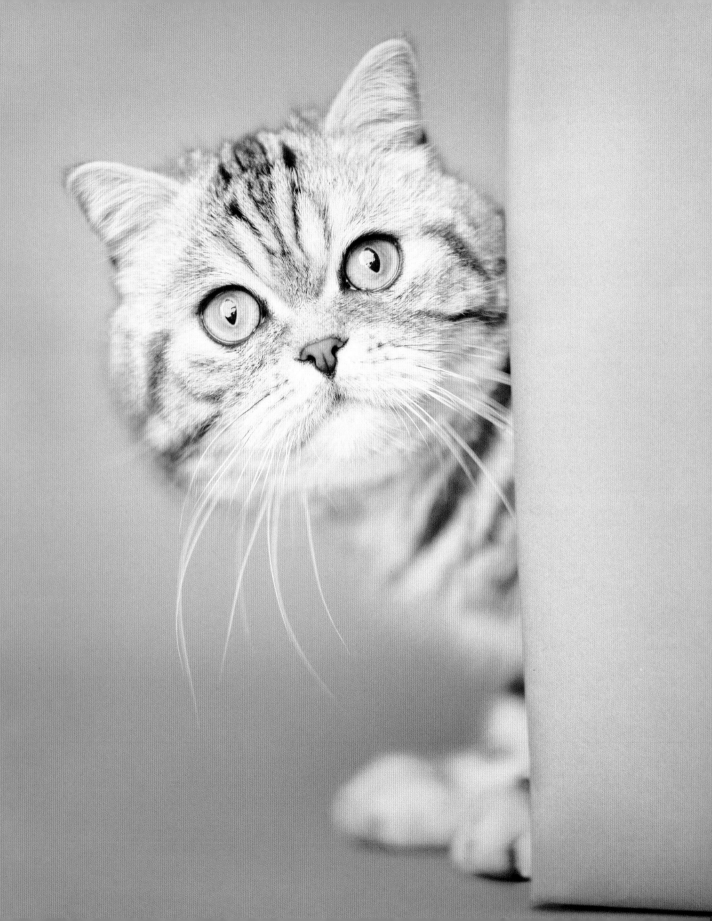

**11. British Shorthair**  Silver Tabby

The Tabby British Shorthair can come in three coat patterns—the classic, the mackerel, and the spotted, and each pattern can appear in a wide variety of colors. The Silver Tabby is considered to be the most popular variety of tabby, and the friendliest. Defined by jet black markings standing out against a silvery gray ground color, the Silver Tabby British Shorthair is nothing short of beautiful.

## 12. British Shorthair  Black Smoke

The result of an unusual coat combination where a different topcoat color covers a white or silver undercoat, the Smoke British Shorthair is truly enchanting. In repose the cat appears as a solid color, but in movement the white undercoat is revealed, producing an effect like shot satin.

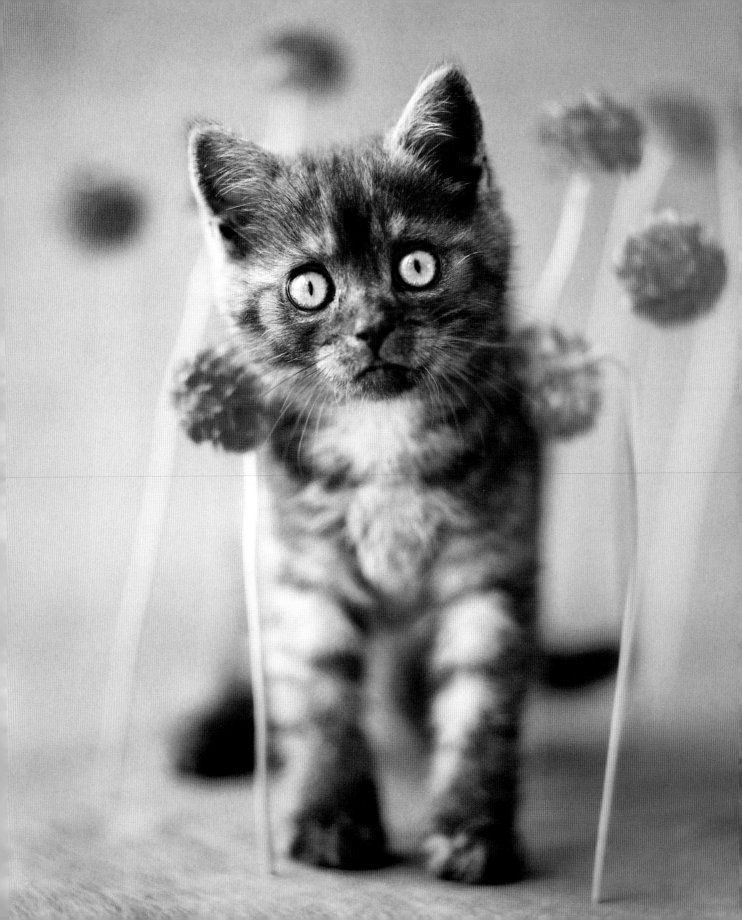

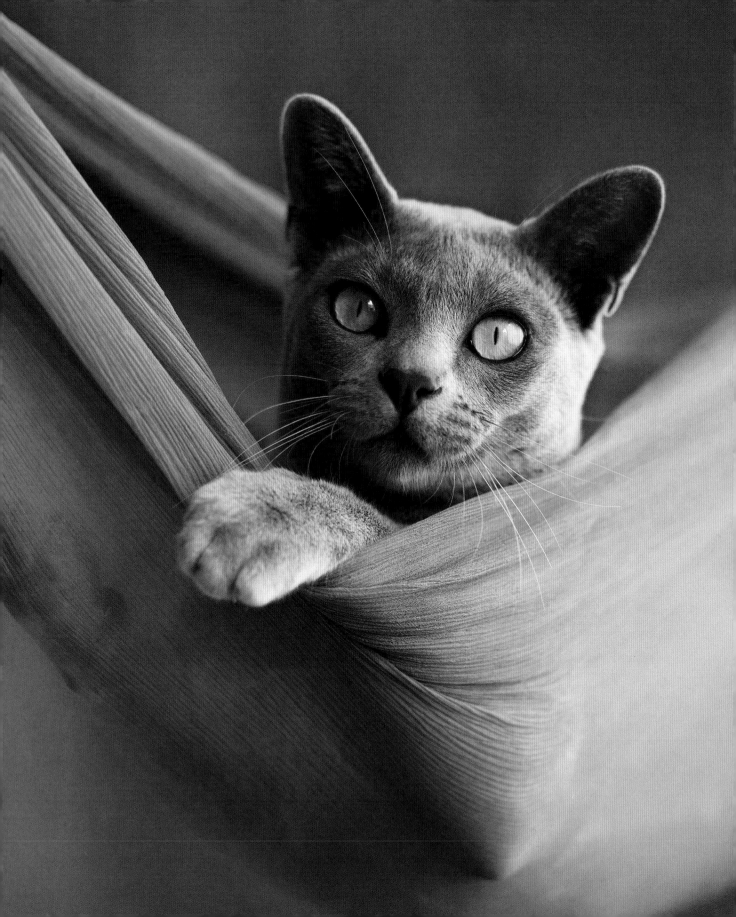

### 13. Burmese  Blue

Athletic and agile, the Burmese is an inquisitive and energetic character that is not shy of adventure. The Burmese is a descendant of the "Rajah," a brown cat from Burma that was once a resident of the Buddhist temples around the 15th century. In the 1930s, a Dr. Joseph Thompson returned to San Francisco from Burma with a dark brown cat he named "Wong Mau." Wong Mau was bred to a Siamese of similar coloring and the offspring of this union are said to be the first of the Burmese line. Intelligent and loyal, the Burmese loves being a part of the action and would much prefer to be in the company of a human or another animal than be left alone.

*Appearance: A medium-sized breed, the handsome Burmese is a well-muscled and sturdy cat. Wide cheek bones sit in a round head with wide-set, medium-sized eyes. The coat is short, dense, and plush, giving a satin finish.*

*Color: The traditional Burmese color and the most widely known is the walnut brown. Popular variations are chocolate (also known as champagne), sable, blue, and platinum. The glossy coat of the Blue Burmese is a soft silver-gray that appears very slightly darker on the back and tail.*

**14. Burmese** Chocolate

The extremely handsome Chocolate Burmese—
also referred to as Champagne Burmese—wears a
warm honey beige coat fading to a pale gold tan
on the underbelly. The coat is highlighted by a slight
darkening on the ears and face, while the eyes
range from yellow to gold.

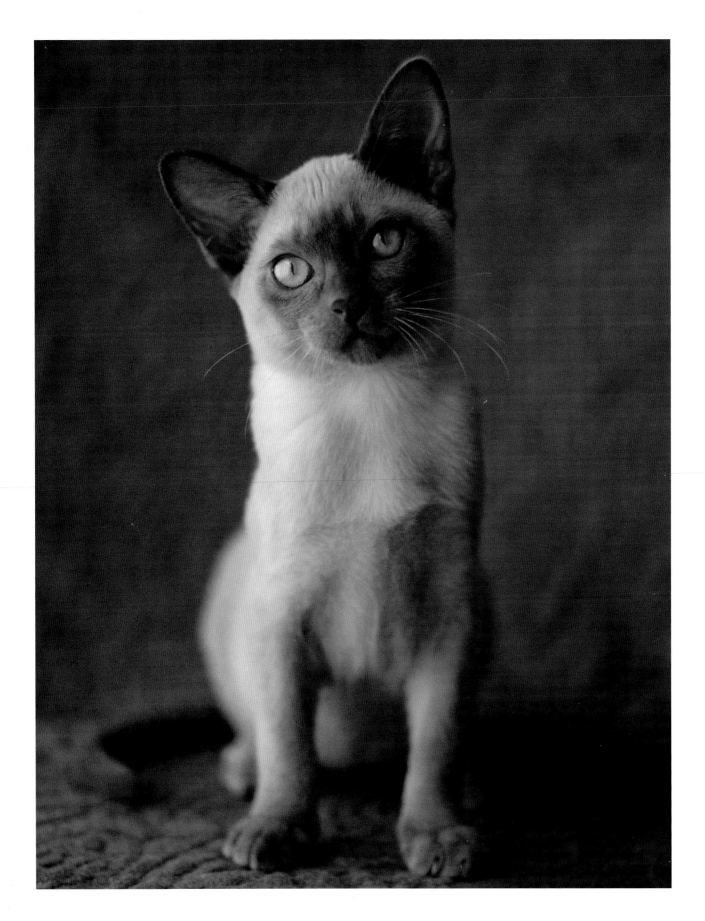

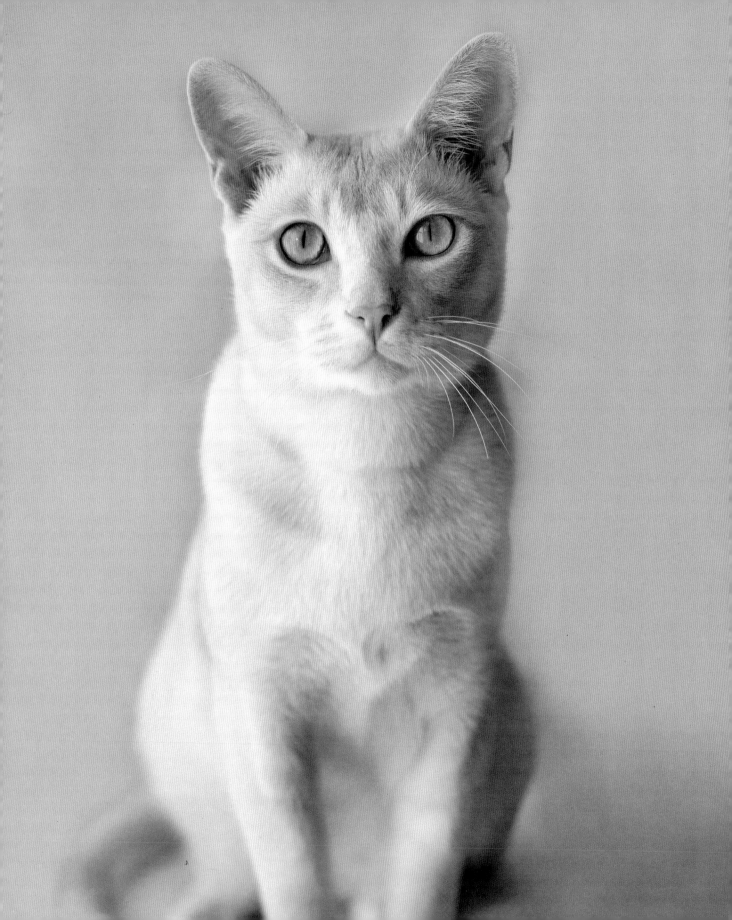

**15. Burmese** Cream

The delicate Cream Burmese is a dilute version of
the Red Burmese. The pale and soft cream color
shows with a very slight Himalayan effect.

Her function is to sit and be admired.

GEORGINA IDA STICKLAND GATES

### 16. Burmese Lilac

The lilac color, originally considered an "inferior blue," is today widely accepted and admired as a new variety. The Lilac Burmese has a pale and delicate coat ranging from bluish lilac to fawn, which produces a subtle pinkish body tone.

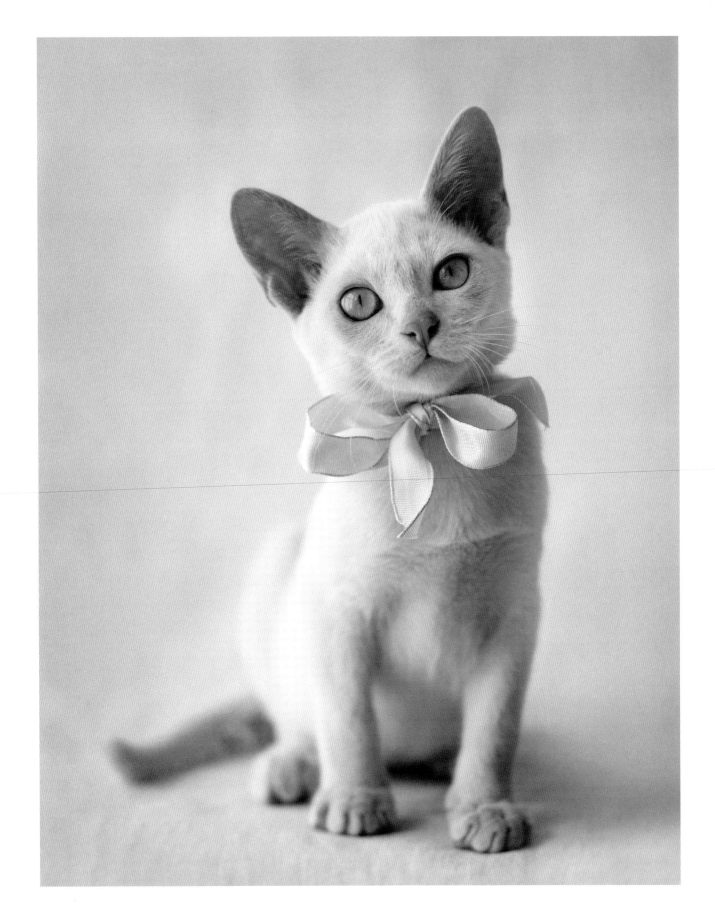

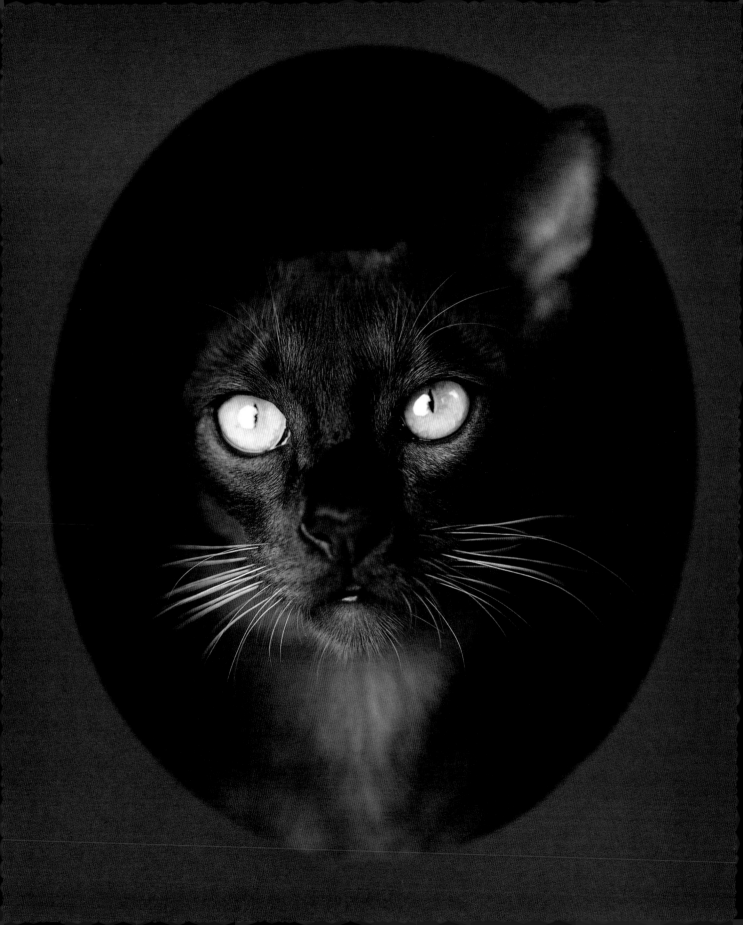

### 17. Burmese  Seal

The brilliance of the Seal Burmese lies in the purity and strength of the rich brown color, which only shades to a softer hue on the underside of the coat. The Seal Burmese has eyes of lustrous gold to yellow.

## 18. Classicat  Chocolate

The loyal and affectionate Classicat is essentially
an Ocicat with a classic tabby coat. The Ocicat
was developed in the 1960s by interbreeding the
Abyssinian, Siamese, and American Shorthair to
produce a spotted "wildlike" cat (in appearance
only). It can have offspring that show no spots but
present in the classic tabby pattern, similar to the
American Shorthair ancestor. The beautiful tabby
pattern is made up of eye-catching whorls and a
striking bull's-eye pattern. This modern breed is
gaining in popularity and has been embraced in
New Zealand where it was named Classicat. A true
socialite, the Classicat will eagerly show off to family,
friends, and strangers. However, while it may welcome
strangers into its life, its true loyalty lies with its
family and it is this extreme devotion that sees
the Classicat likened to a dog. Added to this, its
intelligence and friendliness make the Classicat a
perfect family pet.

*Appearance: The graceful Classicat is athletic and
muscular, essentially of Ocicat type only presenting
in the Classic Tabby pattern, with a characteristic
close-lying coat.*

*Color: Tawny, chocolate, fawn, blue, lavender,
and silver.*

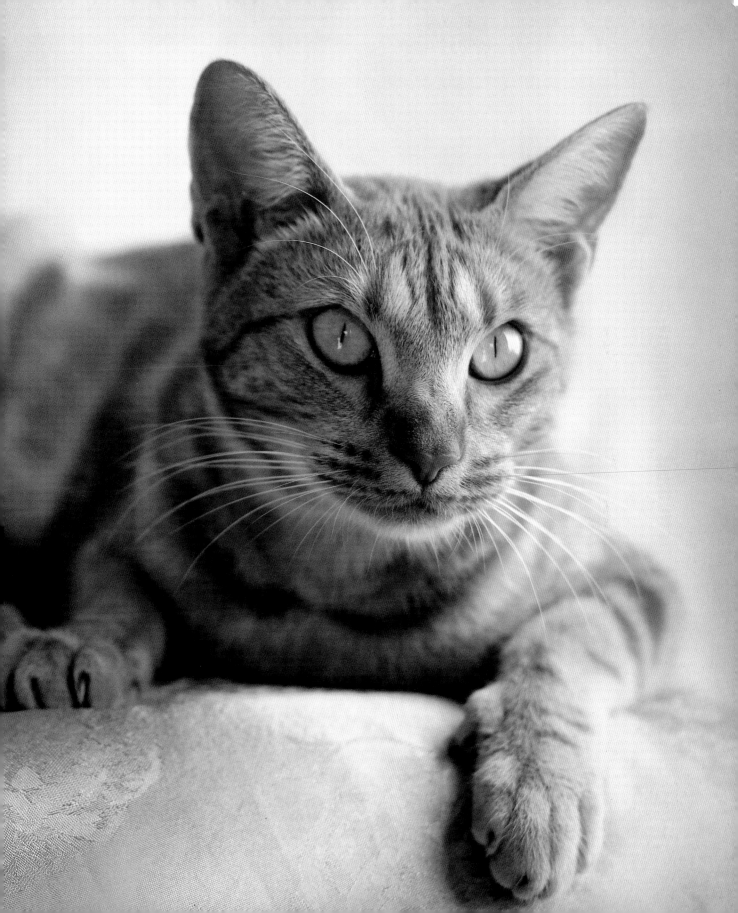

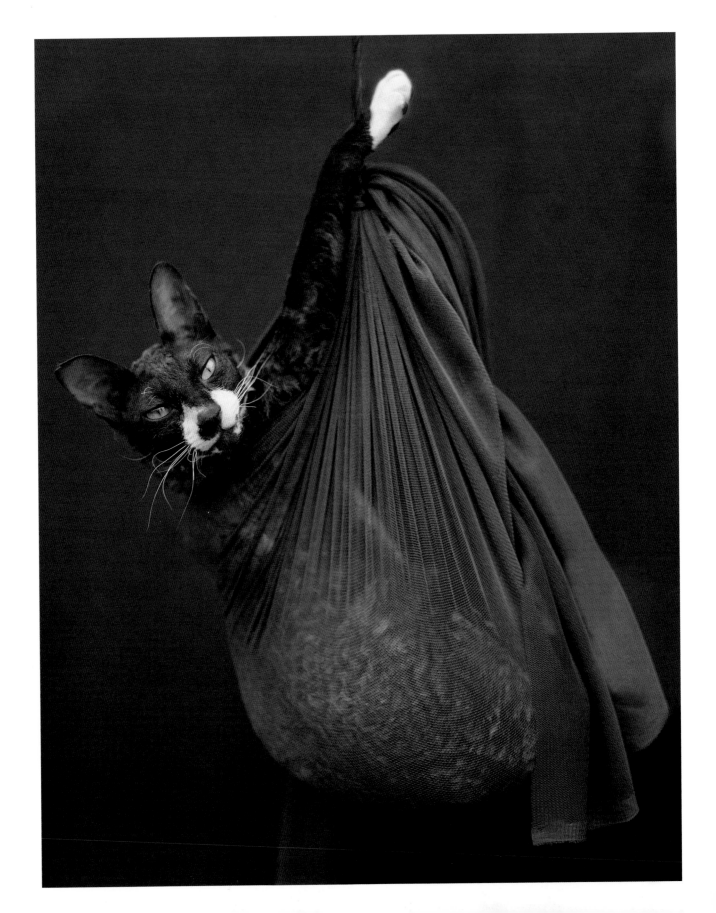

## 19. Cornish Rex  Brown and White

The striking Cornish Rex is famed for its washboard-like fur, large pointed ears, and egg-shaped head. Lean and long with a natural arch of the back, the Cornish Rex is often called the "greyhound" of the cat world. An English breed named after the place of its origin, Cornwall, as well as the Rex rabbit for the similarities of its curly coat, the breed was first discovered in a litter of barn cats in 1950. From this litter came a remarkable looking male kitten with an unusual wavy coat. Named "Kallibunker," all Cornish Rex can trace their ancestry back to this male kitten. Extremely high-spirited and intelligent, the Cornish Rex loves nothing better than playtime and is known for its inventiveness in creating new and exciting games. Also known for its sweet and affectionate nature, the Cornish Rex makes a loving and fun companion.

*Appearance: Curls from head to tail, even including the whiskers, make the Cornish Rex an eye-catching breed. The coat is exquisitely soft, silky, and short, emphasizing the long and slender angles of the body, tail, and nose.*

*Color: The Cornish Rex appears in all colors and patterns.*

## 20. Cornish Rex  Cream

Considered to be an "old" color, and one of the first exotic colors, the cream coat is actually a diluted red. From warm pink creams to cool creams, the cream tone can vary between breeds with the palest of hues being highly sought-after.

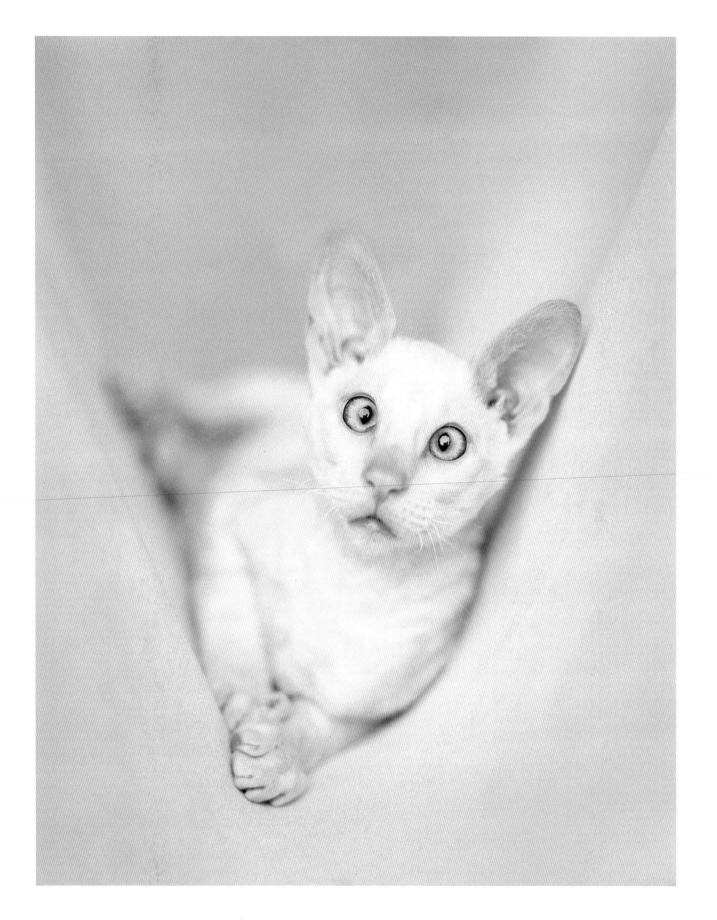

**21. Devon Rex**  Blue Tabby

The inquisitive and fun-loving Devon Rex is the "pixie" of the cat world. Named after the place of its discovery, the county of Devon, England, the Devon Rex appeared as a similar natural mutation ten years after the birth of near-neighbor the Cornish Rex. However close the breeds are in appearance and location, the Devon Rex is genetically different and is therefore viewed as a separate breed. The Devon Rex can trace its ancestry back to a single cat named "Kirlee," who was the offspring of a stray tom cat that carried the breed's characteristic wavy coat. Kirlee was adopted by a Miss Beryl Cox and eventually successfully bred. Though slight in appearance, the Devon Rex is anything but small in personality. Labelled "a monkey in cat's clothing," the Devon Rex is renowned for its climbing ability and cheeky attitude.

*Appearance: Elfinlike features with huge batlike ears and large rounded eyes set wide apart on a very short muzzle make the Devon Rex unique. The compact body is covered almost solely by an undercoat of loose waves and curls of downy hairs.*

*Color: The Devon Rex appears in all colors and patterns.*

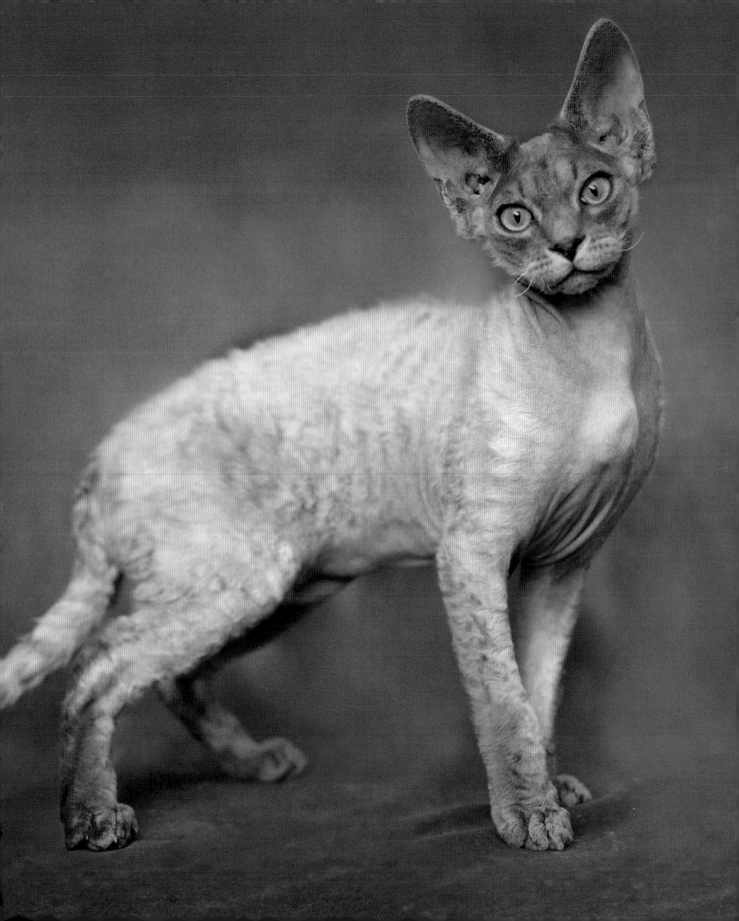

When I play with my cat,
who knows whether she isn't
amusing herself with me
more than I am with her?

MICHEL DE MONTAIGNE

## 22. Devon Rex Cream

The Cream Devon Rex's rich warm body tone is due
to the splashes of red among the cream. Bewitching
blue eyes stand out against the traces of red, and
the warm cream is once again enhanced by the
touch of pink of the nose leather.

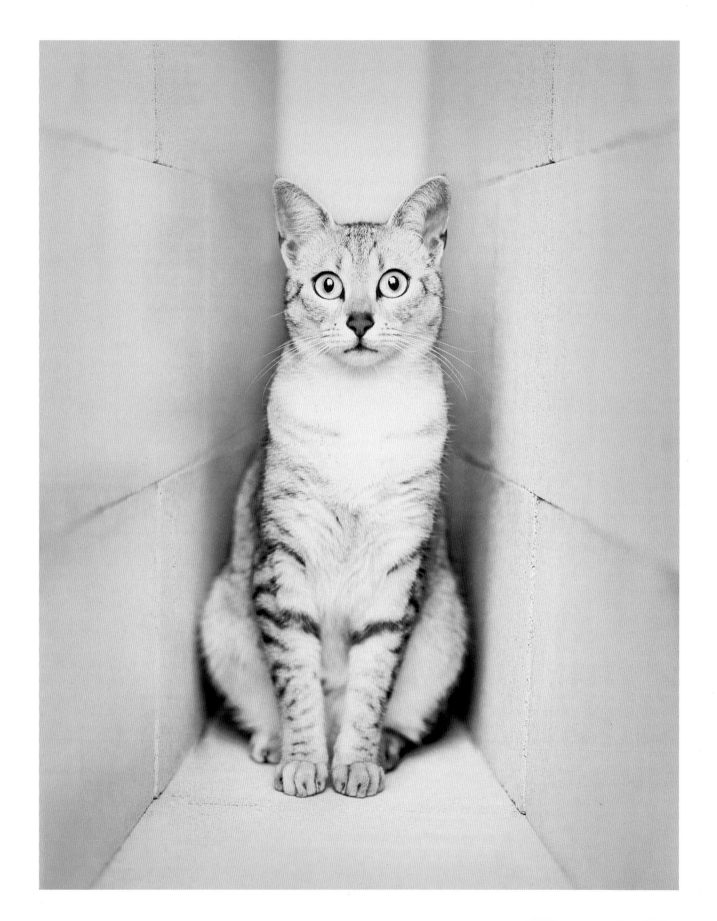

### 23. Egyptian Mau  Silver

A breed of great antiquity, the beautiful Egyptian Mau is considered by many experts to be a descendant of the African wildcat. It was revered by the ancient Egyptians ("mau" is the Egyptian word for cat): worshipped, protected by laws, treasured, and mummified. In 1955 the Egyptian Mau made its showing debut in Rome, following importation to France by the exiled Russian Princess Natalie Troubetskoy. It was not until the princess moved to the United States in 1956, taking with her three Egyptian Maus, that successful breeding of this striking cat was achieved. Fiercely loyal and known to shy away from strangers, the Egyptian Mau finds comfort in devoting itself to its family, preferring to attach itself to a particular person. Extremely intelligent, the breed is naturally active and can be taught several tricks including being walked on a leash.

*Appearance: The medium-sized Egyptian Mau is strong and muscular with a characteristic "M" marking on the forehead. The only naturally spotted domestic cat, it is also known as "Spotted Tabby Oriental."*

*Color: Silver with charcoal markings, bronze with dark brown markings, and smoke with jet black markings.*

## 24. Exotic Shorthair Tortoiseshell/Blue

The popular Exotic Shorthair is a variation of the Persian cat. It was first developed in the United States during the 1950s to fulfill a demand for an easy-care Persian type, the answer being to genetically breed the Persian to retain all its personality traits while shortening the length of the coat. Success came when the Persian was bred with the American Shorthair. In 1966 the name "Exotic" was adopted, and the following year the breed was first shown under the new title. Like the Persian, the Exotic Shorthair is gentle and quiet, and a true homebody. Affectionate and loving without being demanding, the breed has risen steadily in popularity since its establishment. In addition to its placid disposition, the Exotic Shorthair loves playtime, even as an adult, making it a wonderful family pet.

*Appearance: Similar in appearance to the Persian, the flat face and stocky body on short legs have the added unusual short coat that is thick, soft, and luxuriant.*

*Color: The Exotic Shorthair appears in most colors.*

**25. Exotic Shorthair**  Red Tabby

Warm tones of red make up the handsome Exotic
Shorthair Red Tabby's coloring, from the soft red
of the ground color to the rich, deep red of the
markings. Copper eyes and a brick-red nose and paw
leather complement the coat. The Exotic Shorthair
can appear in either the classic, mackerel, or spotted
tabby pattern.

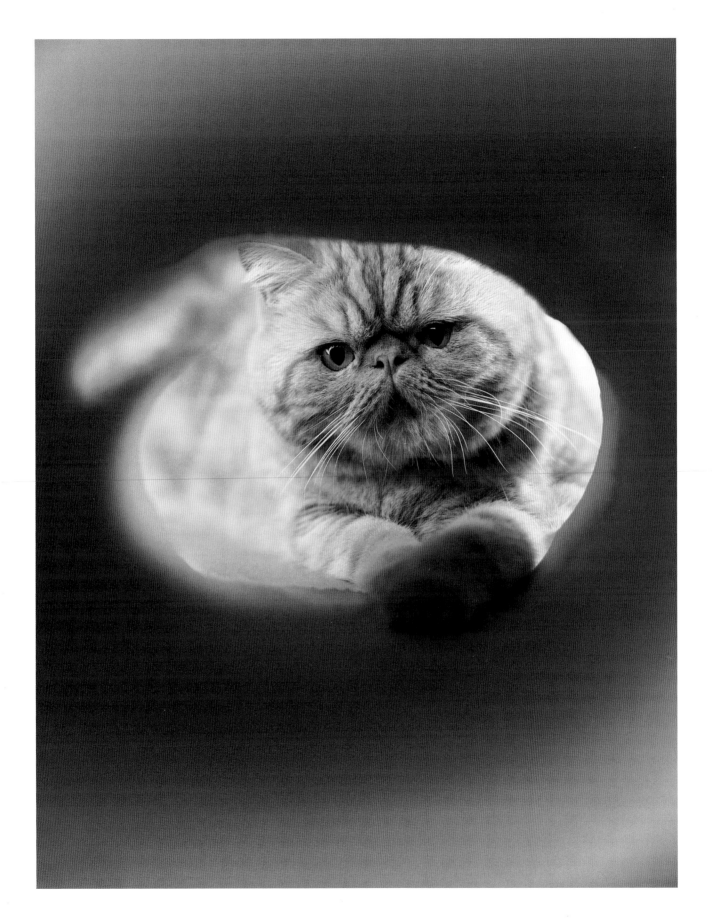

Few animals display their mood via facial expressions as distinctly as cats.

KONRAD LORENZ

**26. Exotic Shorthair**  Blue Point

The Blue Point Exotic Shorthair has a very subtle blue tint to its white coat, gently complemented by a darker blue on the points of the nose, paws, tail, and ears. The vivid blue eyes complete its refined appearance.

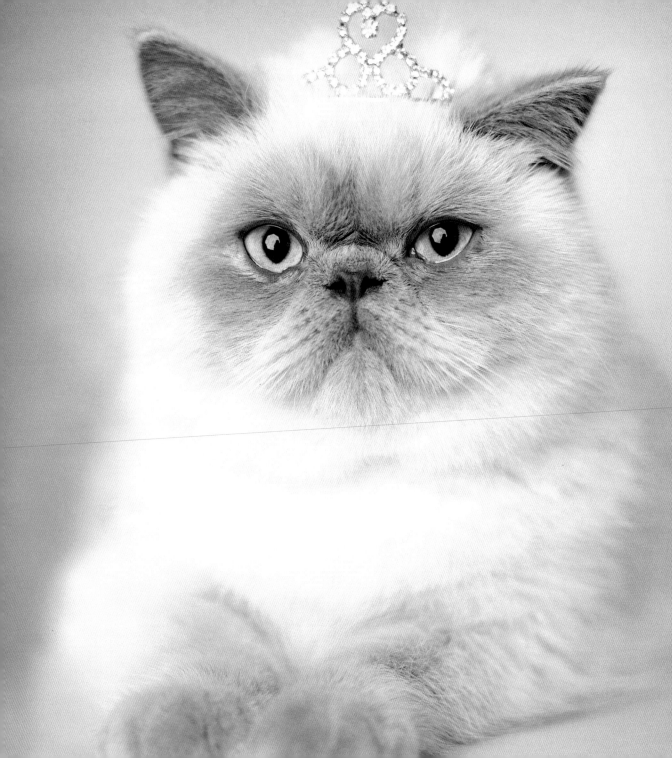

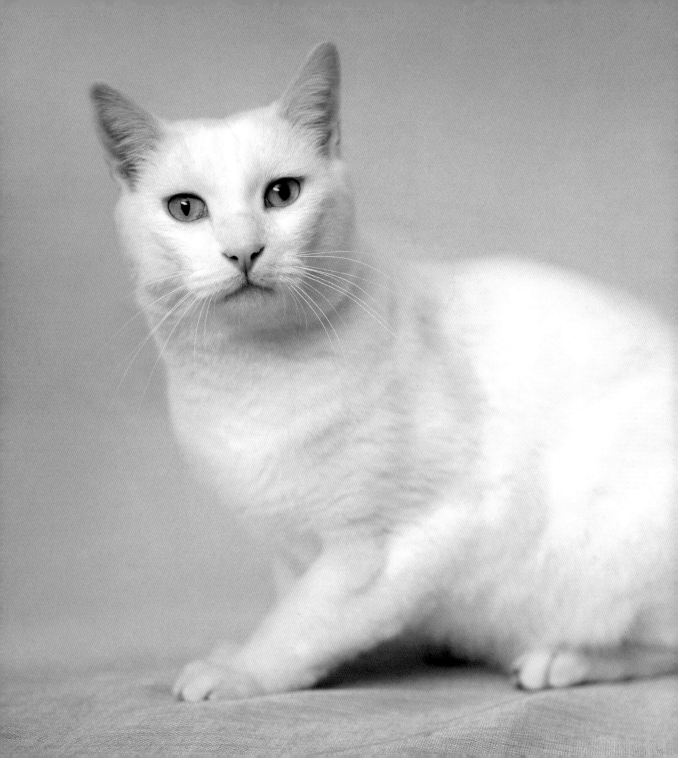

## 27. Japanese Bobtail  White Odd-Eyed

An ancient Eastern breed with a characteristic pom-pom tail, the Japanese Bobtail—sometimes referred to as "Mi-ke"—has taken pride of place for centuries in its country of origin, Japan. It has been depicted in ancient Japanese scrolls and paintings, and today is the model and inspiration for the famous Japanese symbol of good luck, the waving cat (referred to as "Maneki Neko"). The Japanese Bobtail was first brought to the United States in 1968 where it delighted local breeders, and ten years later firmly established itself with championship status. An incredibly strong and healthy breed, the Japanese Bobtail is also admired for its energy and intelligence. It is full of personality, talkative, and playful, and can amuse its audience by playing fetch, carrying objects in its mouth, and enjoying a ride on a pair of willing shoulders.

Appearance: The Japanese Bobtail is a lean, muscular, medium-sized cat with a sculptured triangular head, large ears, and oval eyes. The signature thick and fluffy tail is a short, tightly curled, or kinked stump, giving the appearance of a rabbit's tail.

Color: The Japanese Bobtail appears in numerous colors and pattern combinations, though the most popular combination is black, red, and white (Mi-ke).

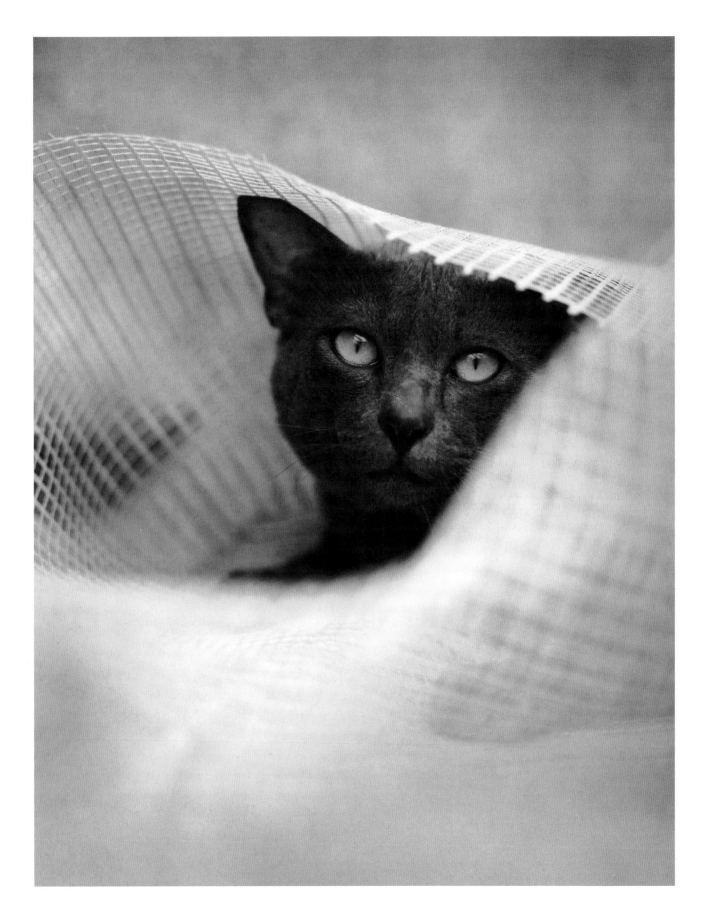

## 28. Korat  Silver Blue

An ancient Thai breed, the Korat is known locally as "Si-Sawat" after the purple-gray sawat nut. Considered a symbol of good fortune, with its silver coat the color of rain clouds and eyes the color of young rice, the Korat is said to bring its owner abundant crops and great wealth. Traditionally, a pair of Korats given to a bride on her wedding day ensured a prosperous union. Named after one of the eastern provinces in Thailand, the Korat is documented in ancient literature and paintings from as early as the 14th century. As the Korat was so revered, the breed was hardly ever sold and examples outside Thailand were extremely rare. The first recording of a Korat in the West was in 1896 in London, and then not again until 1959 in the United States. Faithful and loving, the Korat is an intelligent breed known for its ability to gain its owner's attention. Protective and territorial and especially good with children, it makes a loving family member.

*Appearance: Medium in size, the Korat is compact and muscular. Large, luminous green eyes are set wide apart and accentuate the breed's beautiful and elegant heart-shaped head.*

*Color: The fine and glossy short-haired coat has a delicate silver tipping and can only appear as pale silver-blue all over with no shading or tabby markings.*

## 29. Mandalay  Chocolate

The Mandalay is a modern breed developed from
a string of accidental out-crossings between Burmese
and solid-colored domestic cats in New Zealand
during the 1980s. Two unplanned matings occurred
concurrently in the North and South Islands of
New Zealand, with the same result: a Burmese-type
cat with an enhanced colored coat. And color is the
key factor of the Mandalay breed and the crucial
difference from its Burmese ancestors. Unlike the
Burmese, the Mandalay's coat appears in a wide
variety of vibrant colors combined with a richer
eye color. But like the Burmese, the Mandalay is
an active and intelligent breed that likes to be
an integral part of its owner's life. The playful and
slightly clumsy qualities of the Mandalay combined
with its beautiful appearance make it an extremely
endearing cat.

*Appearance: Essentially a Burmese in type and
temperament, the Mandalay stands out due to its
stunning coat, which presents in a variety of intensified
colors. Medium-sized and well-muscled, the body is
covered by a silky textured, short-haired coat.*

*Color: Ebony, blue, chocolate, cinnamon, lavender,
fawn, red, cream, caramel, and apricot appearing
in a tabby pattern, as well as tortoiseshell in only
caramel, ebony, blue, chocolate, and lavender.*

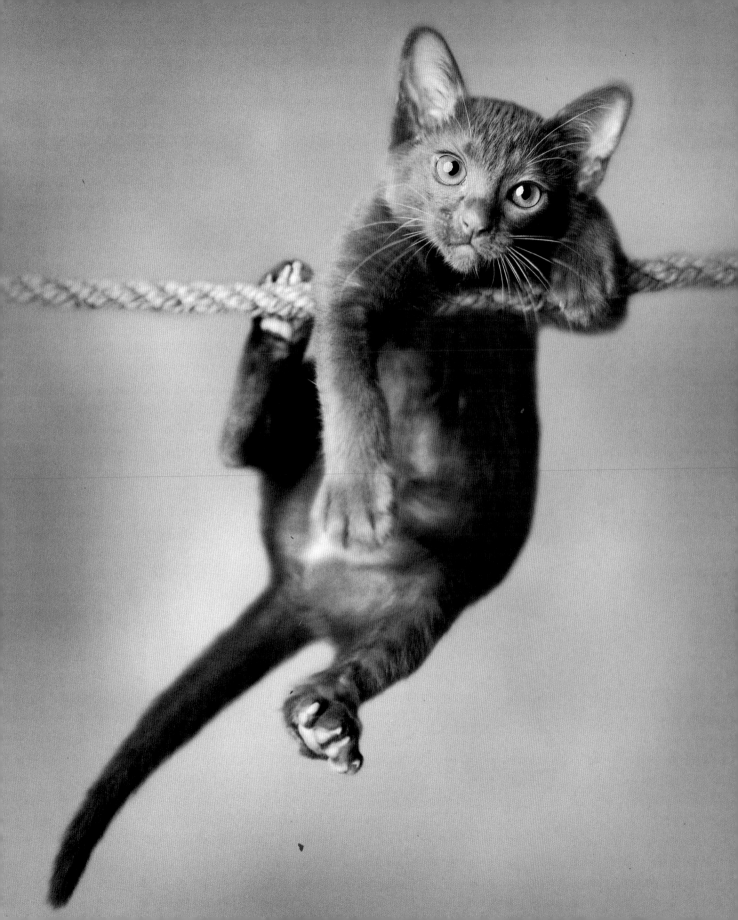

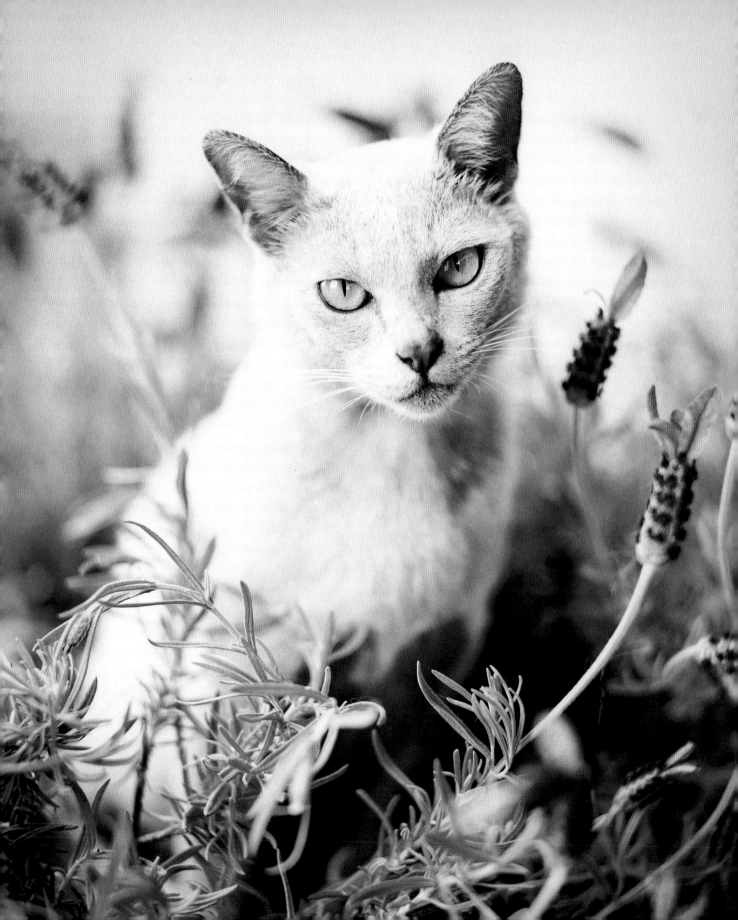

**30. Mandalay** Lavender

The golden eyes of the Lavender Mandalay glow
intensely against the rich lavender body tone, which
should ideally be even throughout. Paw pads are
pink and the nose leather a darker lavender tone.

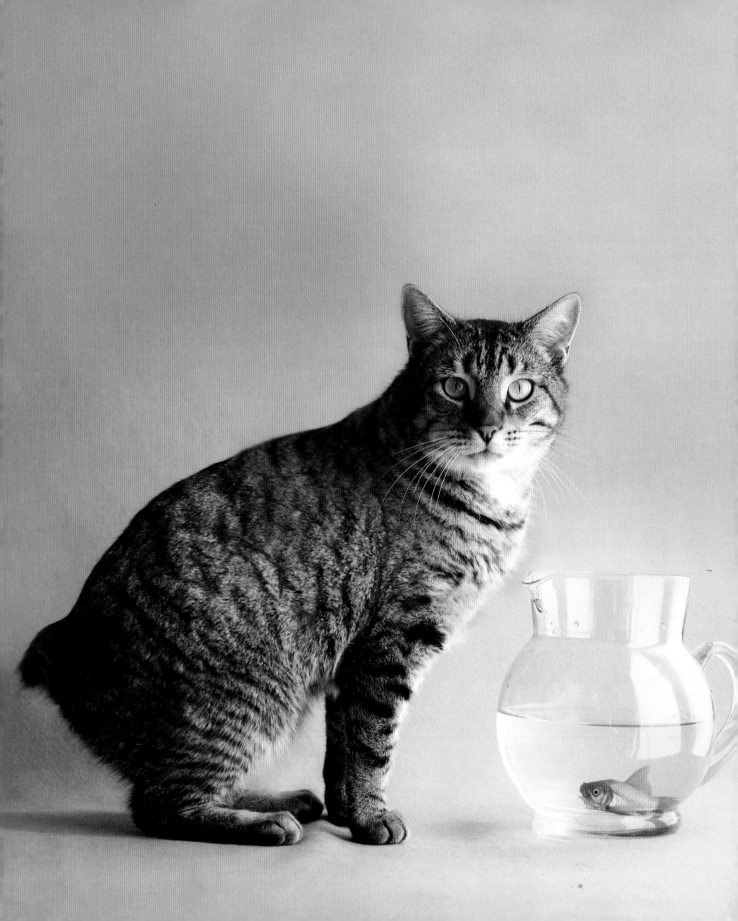

### 31. Manx  Brown Tabby

The playful Manx is an ancient breed. And like all ancient breeds, legends abound. Stories about how the tailless Manx came to be are numerous and range from Vikings stealing the tails as trophies to Noah's own dog biting them off. The Manx actually originated from the Isle of Man, and modern science agrees that its appearance is due to a mutant dominant gene. Known for its intelligence, the Manx is also extremely loyal and generally forms strong ties to one person. Particularly playful, the Manx is also the great jumper of the cat world. Its powerful hind legs are used to balance itself where typically a cat would use its tail.

*Appearance: The signature missing tail of the Manx accentuates the roundness of the breed. The short rounded body is solid and muscular with a very round head and rounded cheeks. Eyes are large, round, and full, with a sweet expression. The heavily boned legs are longer in the hind than the forelegs. There are two types of Manx coat: shorthair and longhair (the latter is known also as the Cymric).*

*Color: The Manx appears in all colors and patterns except for Siamese markings.*

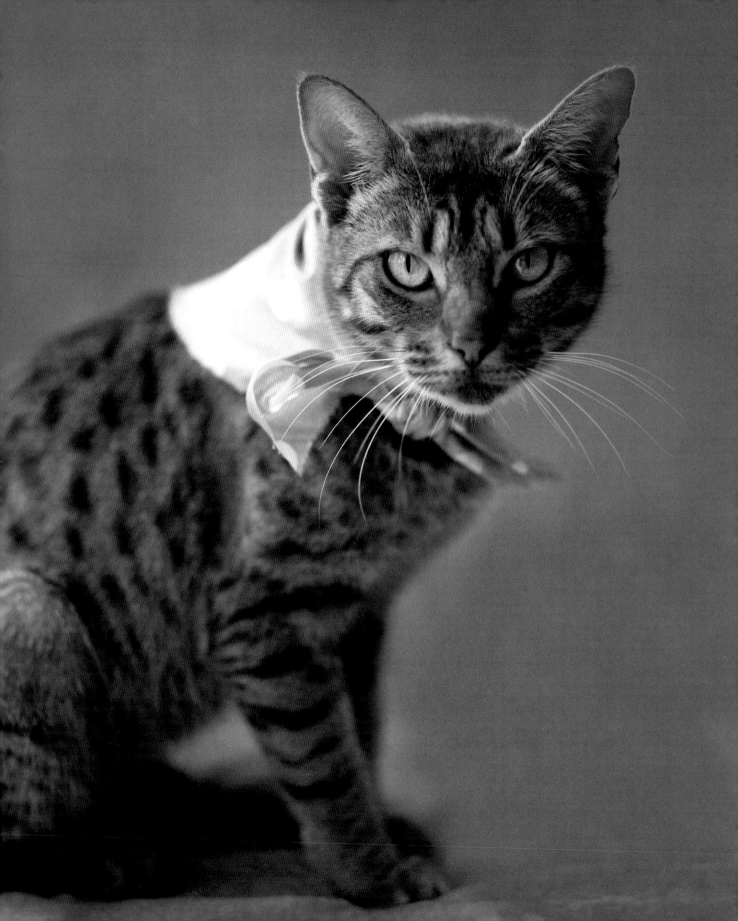

## 32. Ocicat  Chocolate

Intelligent and easily trainable, the Ocicat is a modern spotted cat selectively bred to recapture the "wild look" while maintaining a friendly domestic character. Developed in the United States in the 1960s by interbreeding the Abyssinian, Siamese and American Shorthair, the new breed was named Ocicat because of its similarities to the ocelot. The Ocicat may have a wild appearance but its personality is far from fierce. Friendly and social, the Ocicat welcomes attention from strangers and makes the most of a potential new playmate. Devoted to its owners, the intelligent Ocicat has been likened to a dog because it eagerly learns new tricks, walks on a leash, and responds to commands.

*Appearance: The athletic Ocicat is muscular and solid yet agile. A fine and close-lying coat with all hairs except the tail appearing ticked gives the Ocicat a satin sheen that accentuates the spotted "wild look."*

*Colors: Tawny, chocolate, cinnamon, blue, lavender, fawn, silver, chocolate silver, cinnamon silver, blue silver, lavender silver, and fawn silver.*

## 83. Ocicat  Chocolate Silver

One of the most popular Ocicat combinations, the
Chocolate Silver Ocicat displays chocolate markings
on a silver ground color. This ground color can range
from "cold" indicating pure silver to "hot" signifying
warm russet tones.

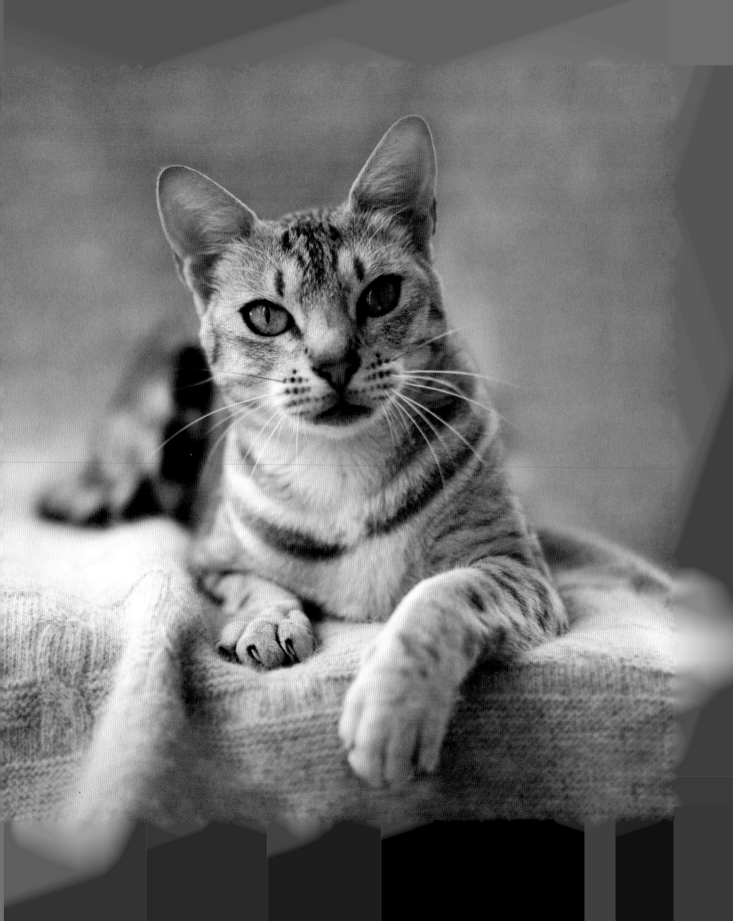

As anyone who has ever been around

a cat for any length of time well knows,

cats have enormous patience with the

limitations of the human kind.

CLEVELAND AMORY

**34. Ocicat** Tawny

The Tawny Ocicat is another popular version of the
breed and appears with black or dark brown spots
on a bronze agouti ground color. The brick-red nose
and glowing eyes are accentuated by a rim of black.

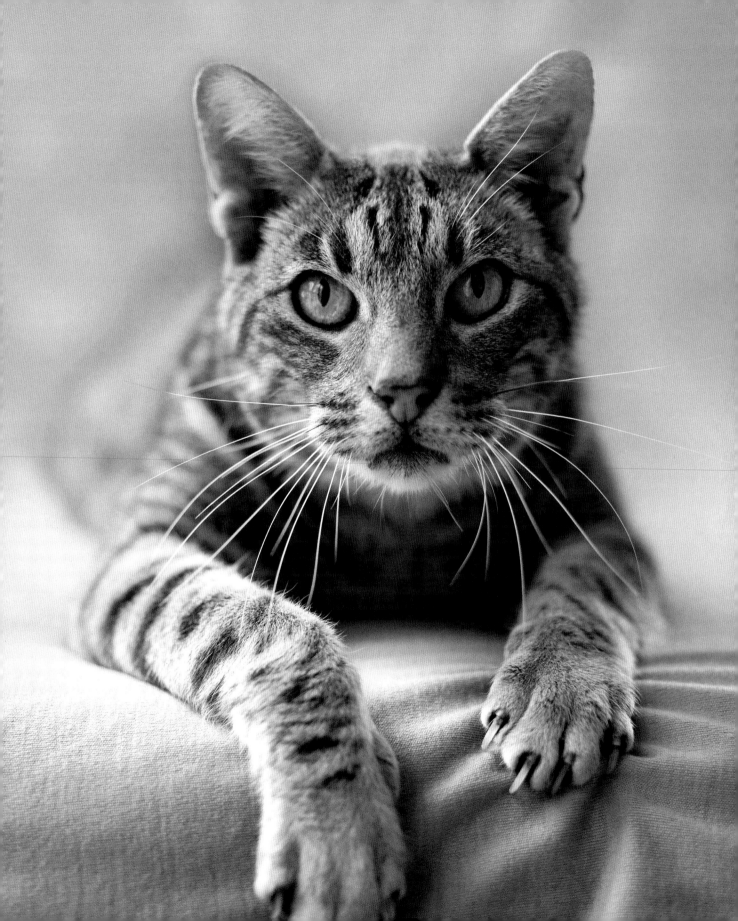

## 35. Russian Blue  Blue

The Russian Blue is an ancient breed that has enjoyed many names including its earliest titles of "Archangel Cat" and "Foreign Blue." Believed to have originated from the Archangel Isles in northern Russia, one legend speaks of the Russian Blue as a descendant of the royal cat of the Russian czars. The breed arrived in England and Northern Europe during the 1860s and was first shown in 1875 at the Crystal Palace in London. English and Scandinavian breeders embraced the cat, each building on separate strengths, but it took American breeders to combine the bloodlines to produce the Russian Blue we know today. The shy and gentle Russian Blue is cautious of strangers and perfectly content to be indoors. An extremely sensitive breed, it is well known for its ability to read its owner's mood and adapt accordingly.

*Appearance: The regal Russian Blue is fine boned and medium in size, with a long and muscular body. A short, dense coat of even blue is tipped in silver giving a silvery sheen. Large pointed ears are set on a cobralike wedge head with beautiful vivid green eyes.*

*Color: The Russian Blue comes in one color only—blue.*

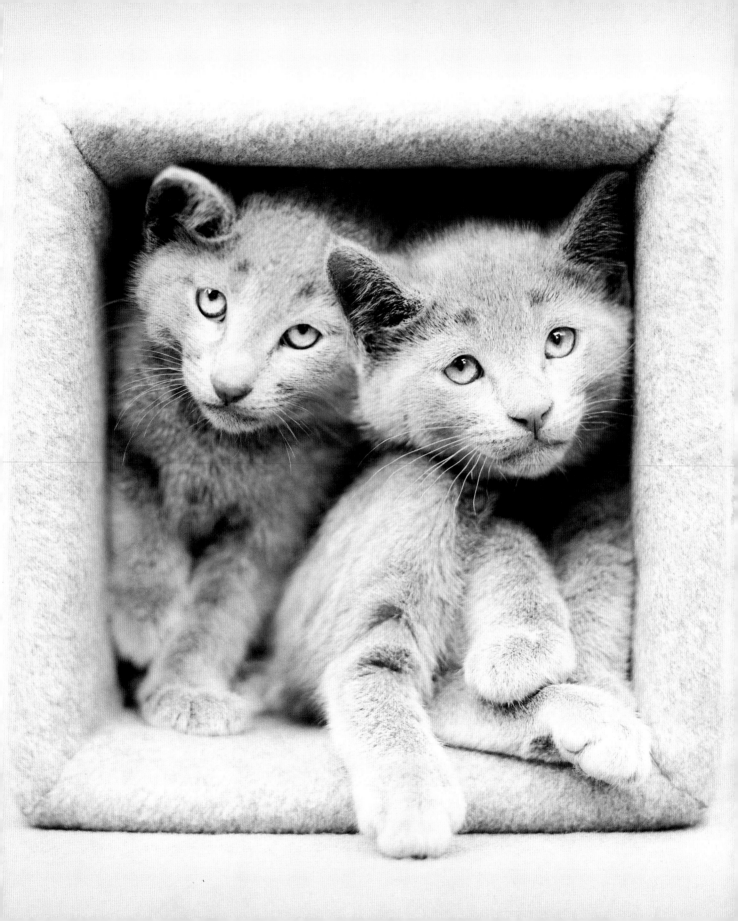

## 36. Scottish Fold  Chocolate

Exceptionally sweet natured and gentle, the Scottish Fold was discovered by a Scottish shepherd in 1961. A single white female kitten was born with strange ears that folded forward and downward on the head, giving the kitten an appealing owl-like appearance. A single male offspring from this original cat, "Snowdrift," became the founding father of the breed. Controversy surrounded the breed in England and eventually the breeding program was exported to the United States in the 1970s. Here the Scottish Fold was embraced, quickly gaining championship status in 1978. A skilled hunting cat, the Scottish Fold is also extremely good with children. The patient and gentle breed loves human companionship and adapts well to new environments and other pets.

*Appearance: The signature folded ears are small and rounded and fold downward on the wide and round head. Powerful and stocky, the body is supported by short, muscular legs. The Scottish Fold can appear in both short- and long-haired varieties with the short-haired coat being nice and thick. The long-haired coat is luxurious, almost hiding the ears from view.*

*Color: The Scottish Fold appears in all colors and patterns.*

## 37. Selkirk Rex  Chocolate

The largest of the Rex family, the Selkirk Rex is the result of a spontaneous mutation occurring in the United States in the 1980s. The upshot of a dominant gene that produces an extremely soft and gently waved or curled coat—it is affectionately termed the "sheepcat"—the Selkirk Rex can appear in both short- and long-haired versions. The name comes from the Selkirk Mountains near where the original kitten appeared in 1987, born among a straight-haired litter of nonpedigree cats. Adopted by Montana breeder Jeri Newman and named "Miss De Presto," she was eventually bred to a Black Persian. Three kittens from that litter carried the curly gene and the trio became the foundation stock of this modern breed. Affectionate and playful, the Selkirk Rex has a sweet and endearing personality. Matched with this, its shaggy coat and stocky physique make it an incredibly appealing breed.

*Appearance: As the "teddy bear" of the Rex group, the Selkirk Rex owes its cuddly appearance to its stocky and muscular body covered in a thick and luxurious coat formed by soft and loose curls or waves. The head is rounded with short, curly whiskers and intelligent eyes shine in copper, gold, yellow, or green.*

*Color: The Selkirk Rex comes in all colors and patterns, including any white markings on any coat pattern.*

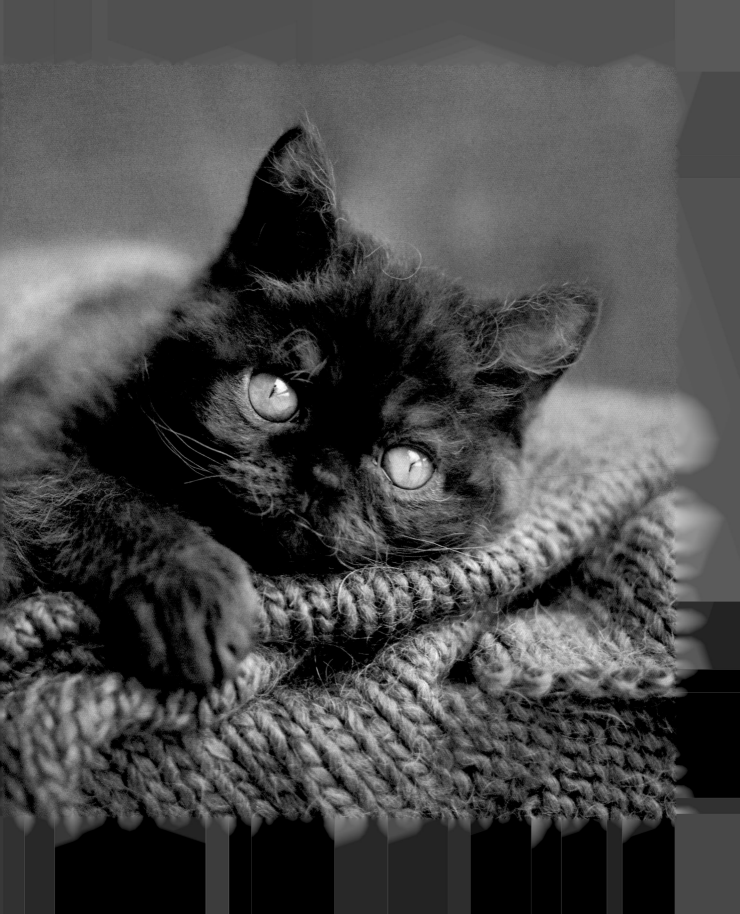

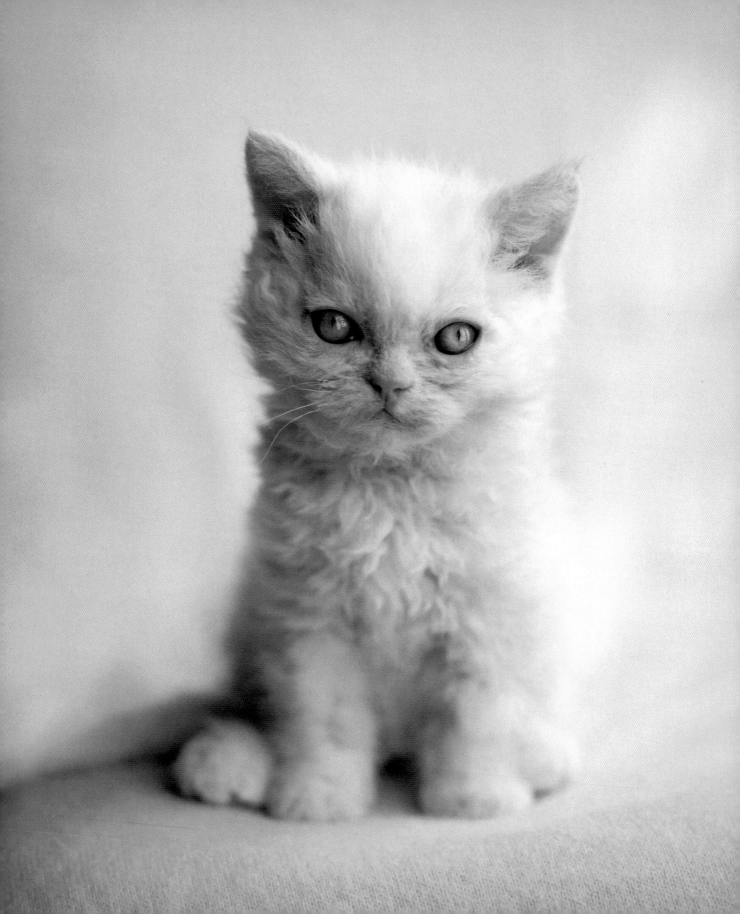

**38. Selkirk Rex** Cream Point

The muted tones of the Cream Point Selkirk Rex—
creamy white with a touch of buff cream on the
points—present a delicate picture that is enhanced
by a kiss of pink on the nose and mouth. Piercing
blue eyes add a touch of drama.

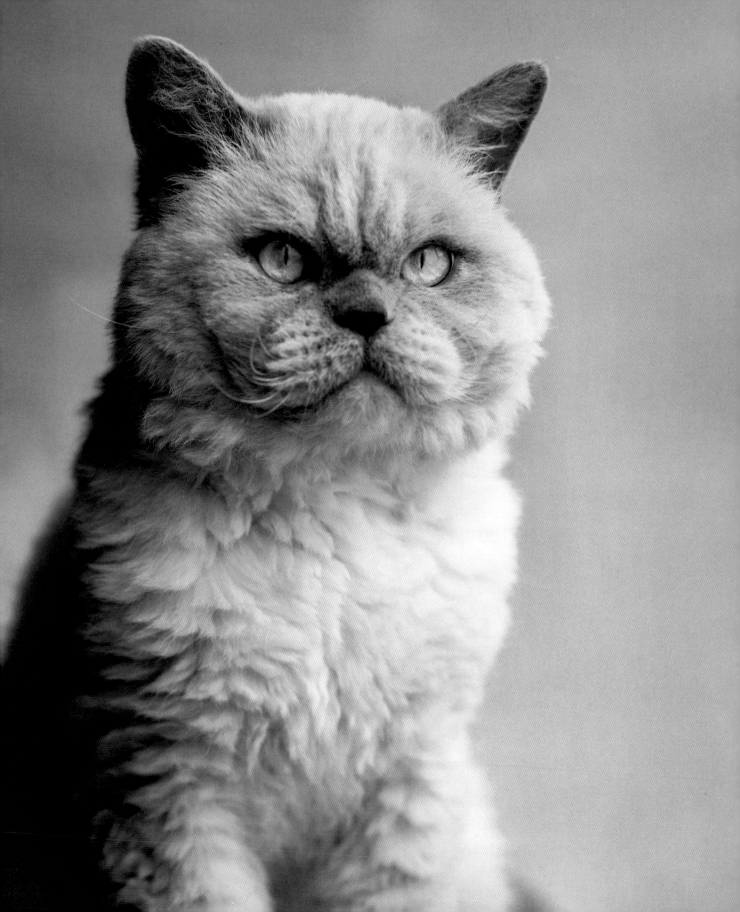

When my cats aren't happy, I'm not happy.

Not because I care about their mood

but because I know they're just sitting there

thinking up ways to get even.

PENNY MOSER

**39. Selkirk Rex** Lilac Point

The Lilac Point Selkirk Rex has an almost polar bearlike quality to it: icy blue eyes are rimmed by frosty gray patches on a body covered by a glacial white coat.

### 40. Singapura  Sepia Agouti

The delicate Singapura is one of the smallest pedigree cats. Originally known as the "Singapore River Cat," as it was believed to have originated from the banks of the Singapore River system, its modern international name is the Malay word for Singapore. Today in Singapore the Singapura is highly valued and has been celebrated with a new name, "Kucinta, the Love Cat of Singapore." Although the Singapura is an ancient breed, the modern history of the Singapura is closely connected to American breeder Tommy Meadows and her husband, who on a trip to Singapore in 1970 noticed unusual silvery-colored cats of an Abyssinian likeness. They returned to the United States with four of these cats and after breeding them successfully the couple returned to Singapore and continued to breed them. Once again returning to the United States in 1975 with their cats, the couple set about establishing the new breed, quickly gaining official recognition. Today the Singapura is a popular breed well-loved for its friendly and gentle temperament. Playful and intelligent, the Singapura adores human companionship and prefers the comfort of indoors.

*Appearance: Although petite, the Singapura is muscular and athletic with a short, close-lying satiny coat. A small rounded head is filled with large striking eyes and framed by large and slightly pointed ears.*

*Color: The Singapura appears only in sepia agouti, sometimes referred to as brown ticked or sable ticked.*

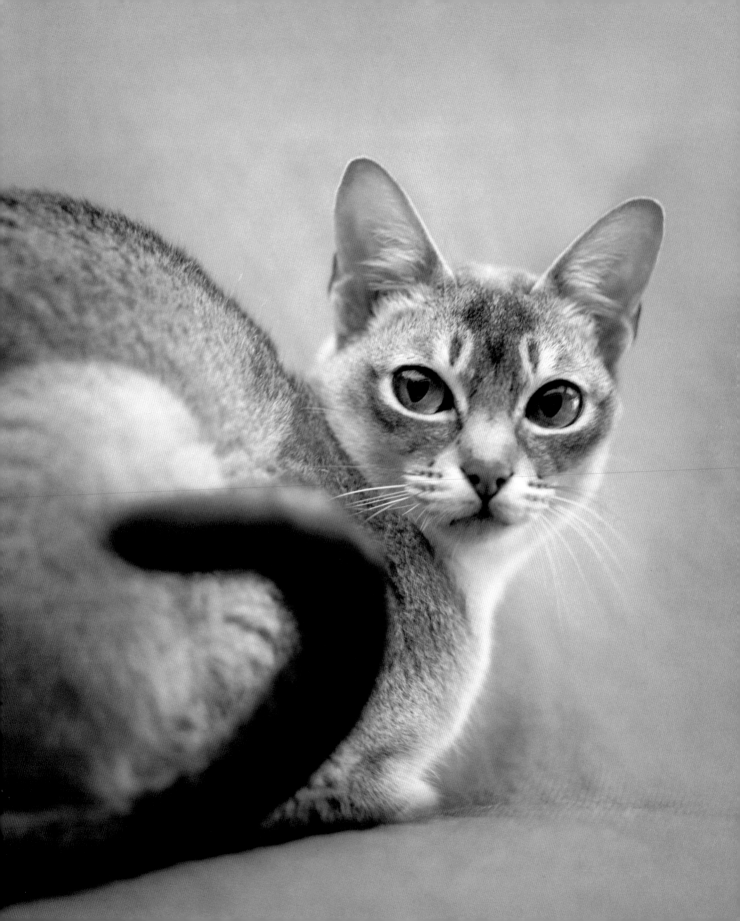

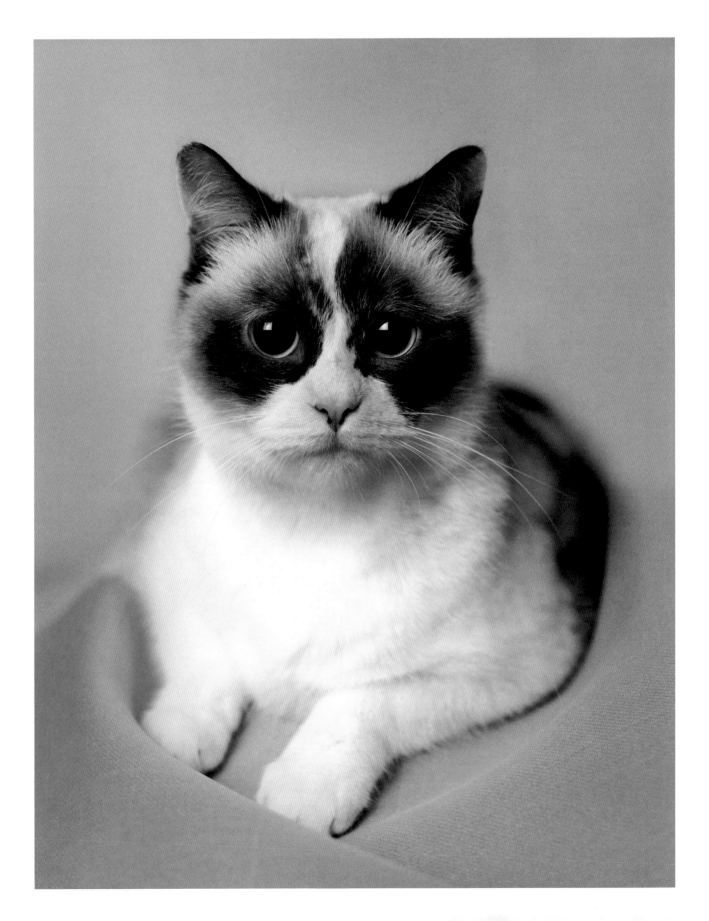

### 41. Snowshoe  Chocolate Tortie

The modern American breed Snowshoe—occasionally called "Silver Laces"—is named for its signature white "snowshoe" feet. The origin of the Snowshoe lies in the Siamese breeding program. White-marked kittens began to appear among the Siamese litters and while they were rejected by most breeders, they caught the attention of American Dorothy Hinds-Daugherty of Pennsylvania, who set about establishing them as a new breed. Passionate about the contrast of the point color and the white feet, she crossed the Siamese with a bicolored American Shorthair. Consequently the Snowshoe combines the length and lankiness of the Siamese with the stockiness of the American Shorthair to produce a well-balanced, strong, and elegant cat. Admired for its gentle and composed nature, the Snowshoe is cool-headed, making it ideal for showing—the breed having gained championship status in the mid-1980s. Loving and affectionate, the Snowshoe is also fairly active and social.

*Appearance: The muscular medium-to-large-sized Snowshoe is covered by a short, glossy point-patterned coat that appears white on the paws. The head is triangular with large pointed ears and large blue oval eyes, and occasionally appears with the desired feature of an inverted facial "V" marking.*

*Color: The signature white face and feet can be contrasted against any Siamese point patterns. Most popular is the seal and white point, and blue and white point.*

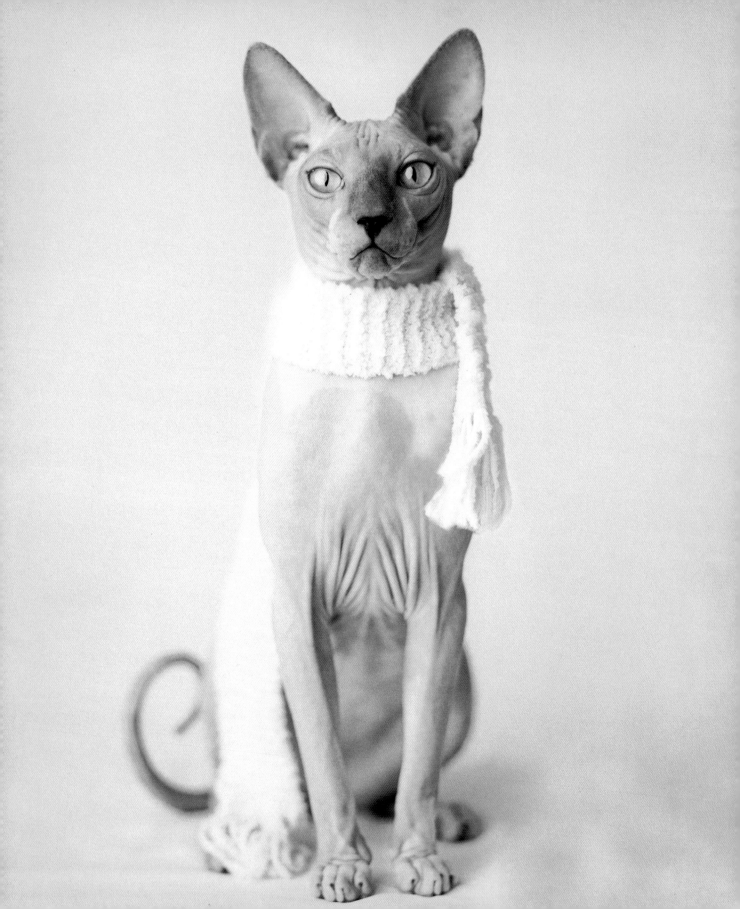

## 42. Sphynx  Bicolor

Slender and naked, the Sphynx is an attention grabber and predictably nicknamed the "Birthday Suit Cat" or "Wrinkled Cat." Though considered hairless, the Sphynx is in fact covered by a very short down. Hairless cats are believed to have been championed by the Aztecs; however, the modern Sphynx originates from a mutant kitten born to a black-and-white pet cat in Canada in 1966. Following the discovery of this particular mutation, a serious breeding program developed. Since then the breed has fascinated the world, eventually achieving championship-class status under the Cat Fanciers' Association (CFA) in 2002. The Sphynx thrives in human company, is extremely affectionate, and loves to be cuddled. Sensitive with a sweet and loving nature, the Sphynx is also known for its intelligent and inquisitive temperament making it a wonderful companion.

*Appearance: The Sphynx's distinguishing nakedness sits on a medium-sized, fine-boned, and muscular body. Eyes are deep-set and lemon-shaped, which complements the very large and round-tipped ears, long slim legs, and whiplike tail.*

*Colors: The Sphynx appears in all colors and patterns.*

## 43. Temple Cat  Cream

The modern Temple Cat is a New Zealand hybrid developed from outcrossing a Birman with a Cinnamon Spotted Tabby Oriental. In the mid-1990s New Zealand breeder June Mateer set about establishing an easy-care Birman type that retained the traditional markings of white gloves and gauntlets. She successfully managed to produce a progeny of beautiful short-haired equivalents of the ancient Birman—a Seal Point Shorthair and a Chocolate Classic Tabby. These two kittens are believed to be the founding stock of the new breed that was originally named Birman Shorthair but later awarded the more eloquent Temple Cat title in 2001. Social and affectionate, the Temple Cat is an easygoing breed that will happily leave its owner in peace if busy but will never turn down a welcoming lap.

Appearance: The Temple Cat retains the Birman's large and stocky build and the magical point markings and white socks. From the Oriental Shorthair it receives its slightly silky but springy-textured short-haired coat.

Color: The Temple Cat appears in the point variations of solid, tortoiseshell, and lynx, and in eight base colors of seal, blue, chocolate, lilac, red, cream, cinnamon, and fawn.

**44. Tonkinese**  Chocolate Lynx

Exceptionally intelligent and extremely beautiful,
the Tonkinese is a perfect blend of beauty and
brains. Born of a Siamese and Burmese mix, the first
Tonkinese appeared in the 1950s, created by the
American breeder Milan Greer. Originally called the
"Golden Siamese," its modern name is a play on
the Gulf of Tonkin, which geographically is close to
the birthplaces of the Siamese and Burmese. Both
the Burmese and Tonkinese breeds can trace their
ancestry back to the famous Wong Mau, imported
from Burma by Dr. Joseph Thompson during the
1930s. Extremely affectionate and social, the
Tonkinese is also a great athlete that loves to
run, jump, and play.

*Appearance: The Tonkinese is a balanced mix of its
ancestors, the Siamese and Burmese. Medium in
size, face, and coat, the Tonkinese presents the dark
points of the Siamese with a touch of the rich body
tone of the Burmese.*

*Color: The Tonkinese appears in a variety of colors.*

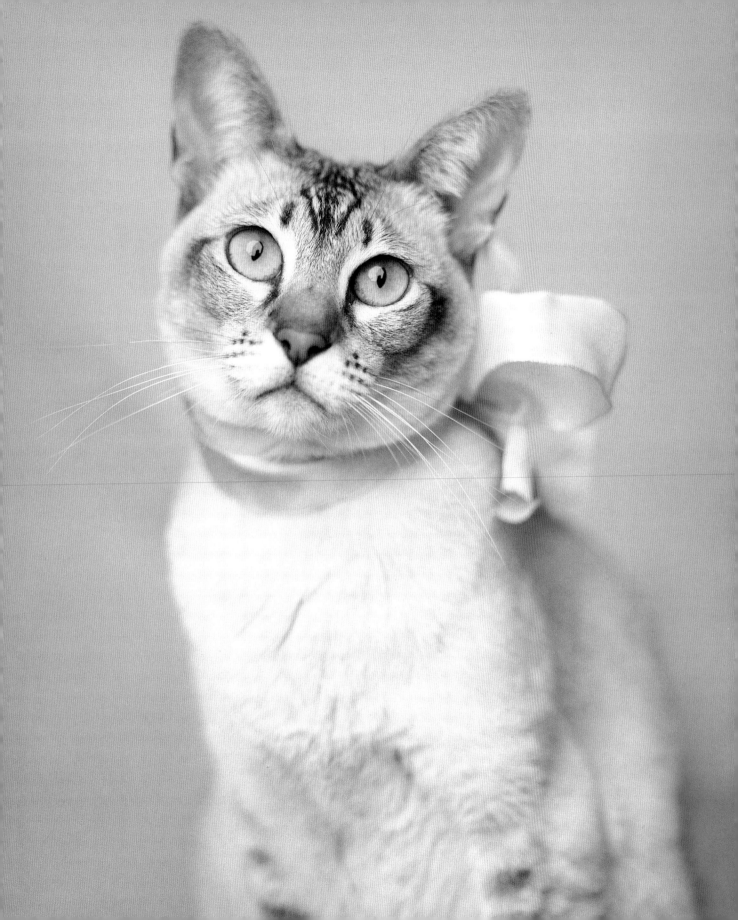

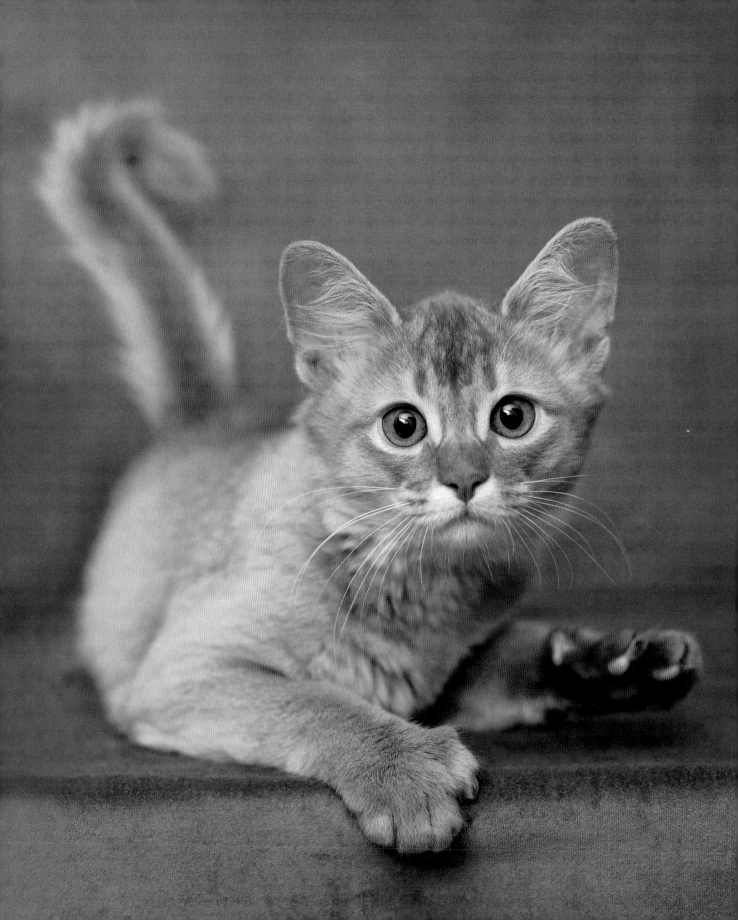

Semilonghair

## 45. Birman  Blue Point

The handsome and majestic semilong-haired Birman
is also called "The Sacred Cat of Burma." Legend
has it that many centuries ago, 100 white cats with
yellow eyes were holy guardians of the Temple of
Lao-Tsun, home to the golden, blue-eyed goddess
Tsun-Kyan-Kse and the high priest and his favorite
cat named Sinh. When the temple was attacked and
the high priest killed, Sinh, who was facing the golden
goddess, placed its paws on its master's body. At
that moment the priest passed through the cat,
transforming it and all its companions to the magical
Birman color, turning the eyes blue and the coat
golden, while the paws remained white. This legend
is perhaps more befitting for such a beautiful cat
than its less magical modern history, which most
agree begins in France in 1919 when a pregnant
female arrived from Burma and gave birth to the
ancestors of the Birman breed we know today. The
Birman has a lively temperament that is well
balanced by a quiet voice and gentle demeanor.
Intelligent and sweet-natured, the Birman is also
a devoted companion.

*Appearance: Medium size, long and stocky in body
with short powerful legs and a large round head, the
Birman has a long and silky coat with its signature
colorpoint and white feet.*

*Color: All Birmans have colorpointed features that
can come in seal, blue, chocolate, lilac, red, or
cream. And no matter what colorpoint, the Birman
will always appear with white gloves and gauntlets.*

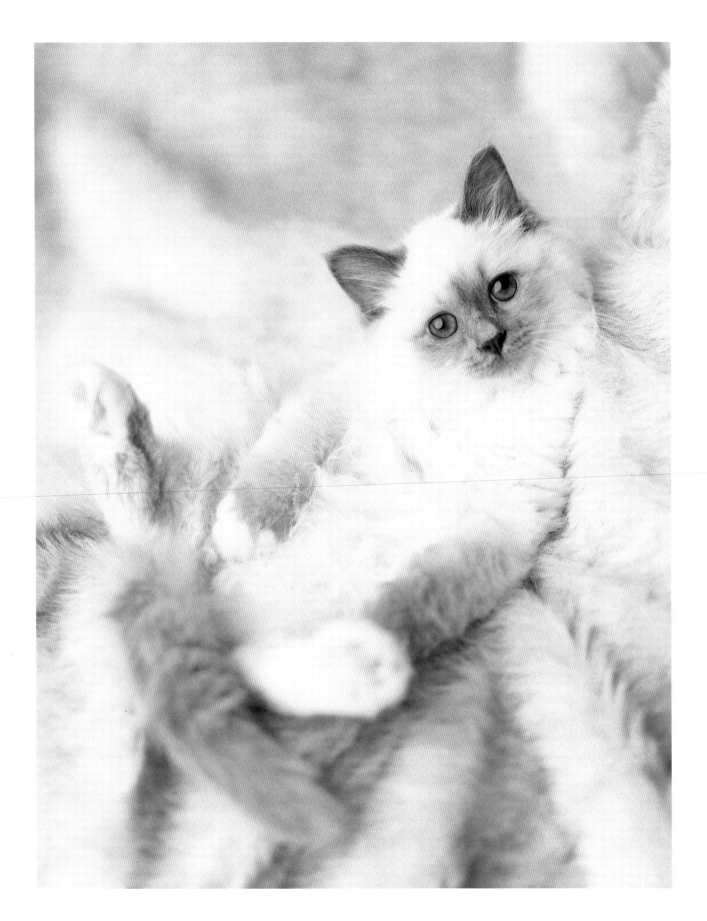

## 46. Birman  Red Point

The large blue eyes of the Red Birman beautifully
highlight the soft cream body color and warm
orange points. The Red Lynx Birman has the magical
"M" marking on its forehead.

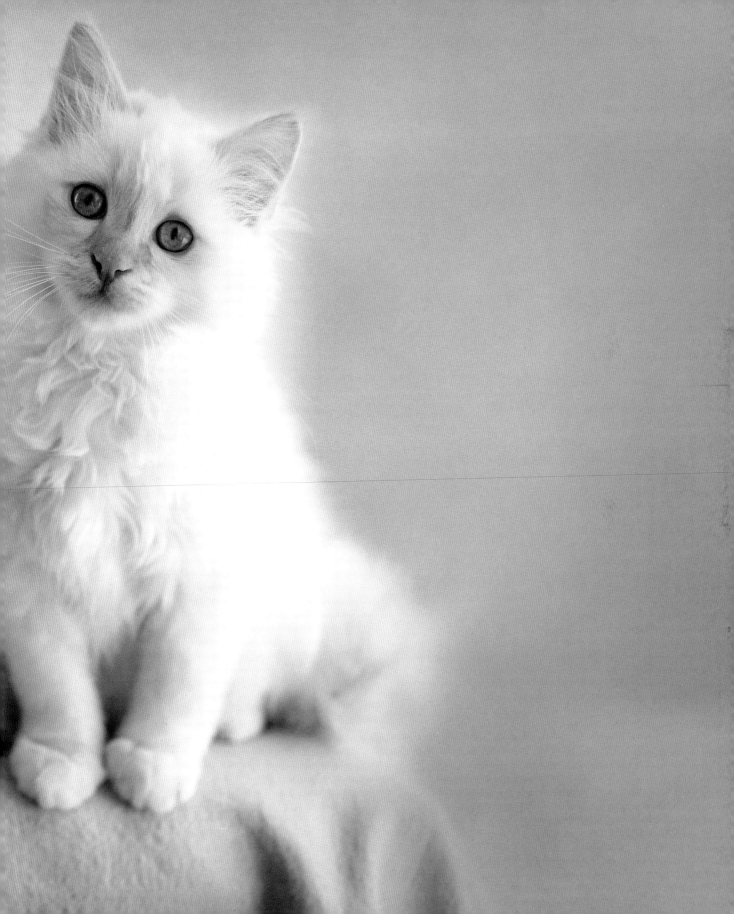

### 47. Cymric  Gray and White

The confident and friendly Cymric (pronounced "kim-rick") is in fact the long-haired version of the short-haired and tailless Manx. The Cymric takes its name from the Celtic word for Wales, "Cymru," due to Wales being close to the Isle of Man—from where the Manx originated—and the breeds having a very close pedigree. The natural mutation was first noticed, but not appreciated, on the Isle of Man where occasionally kittens born to a short-haired Manx carried the long-haired gene. It was not until the 1960s when the natural mutation occurred in a Manx litter born in Canada that the breed was embraced and found to breed true. Cheerful and observant, the Cymric is a gentle breed that likes to form close ties to a single person. Sharp-witted and playful, it is a capable mouser, enjoying both outdoor and indoor living.

*Appearance: Solid and strong, the Cymric is a Manx in every way except for the long-haired coat that is medium length, appearing full around the neck and breeches. A round-looking breed, the Cymric has a round head, large round eyes, and rounded ears. The hind legs are much higher than the forelegs, showing off the signature tail-less rump.*

*Color: The Cymric can appear in all colors and patterns, although colorpoint patterns are less popular.*

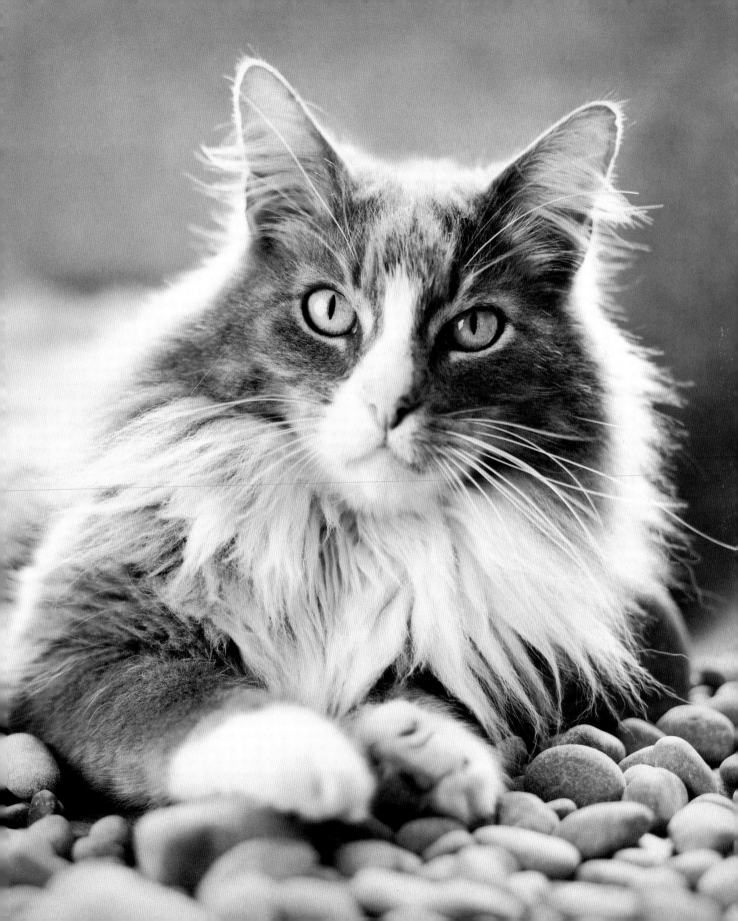

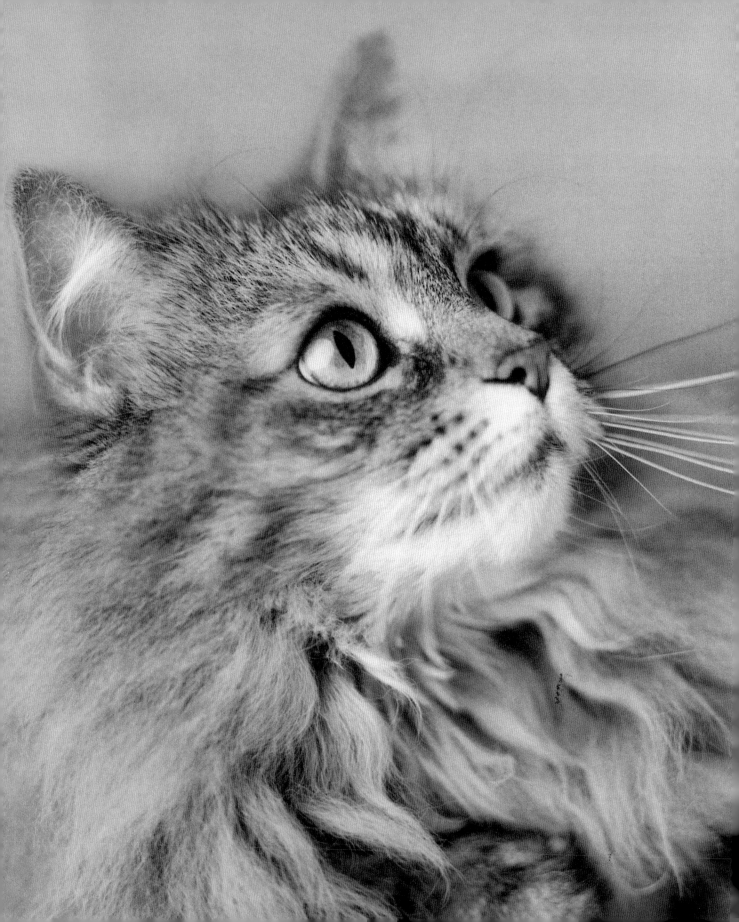

**48. Cymric**  Brown Tabby

The Brown Tabby Cymric has a brilliant coppery
brown coat accented with dense black markings.
Its brick-red nose adds an air of inquisitiveness to
this playful breed.

## 49. Highland Fold  Brown Tabby

The adorable Highland Fold is the long-haired version of the Scottish Fold and is also known simply as the Long-haired Scottish Fold. The longhair gene has been present since the early history of the Scottish Fold, though it became increasingly rare due to the use of other short-haired types during the breed's development. Like its parent breed, the Highland Fold also presents the characteristic folded ear gene that causes the ears to fold forward on the head when the kitten is nearing its first month. This unusual feature—which frames the head and gives the breed its owlish or teddy bear–like appearance—when combined with a long and dense coat makes for a very pretty cat. The Highland Fold has grown in popularity since being awarded championship status by The International Cat Association (TICA) in 1986 and the CFA in 1993. Quiet with a tiny voice, the Highland Fold has a tender and affectionate disposition.

*Appearance: The medium-sized Highland Fold has a dense medium-long-to-long coat and can appear with a full lion's mane, ending with a fully coated plumelike tail. The round face and round eyes confer a sweet expression.*

*Color: The Highland Fold can appear in all colors and patterns except chocolate, lilac, or the Himalayan pattern.*

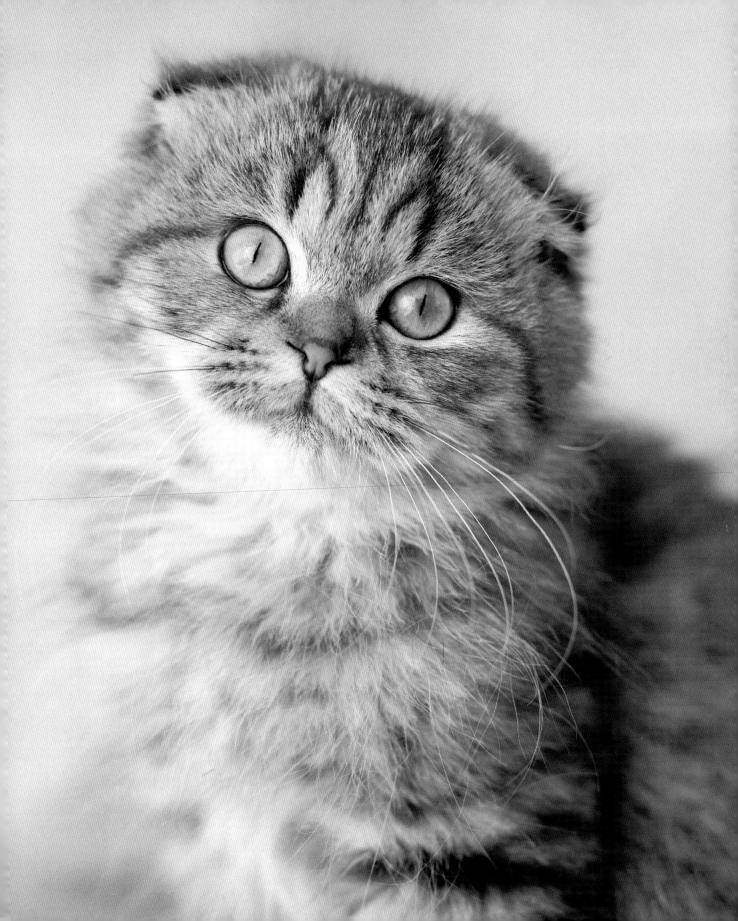

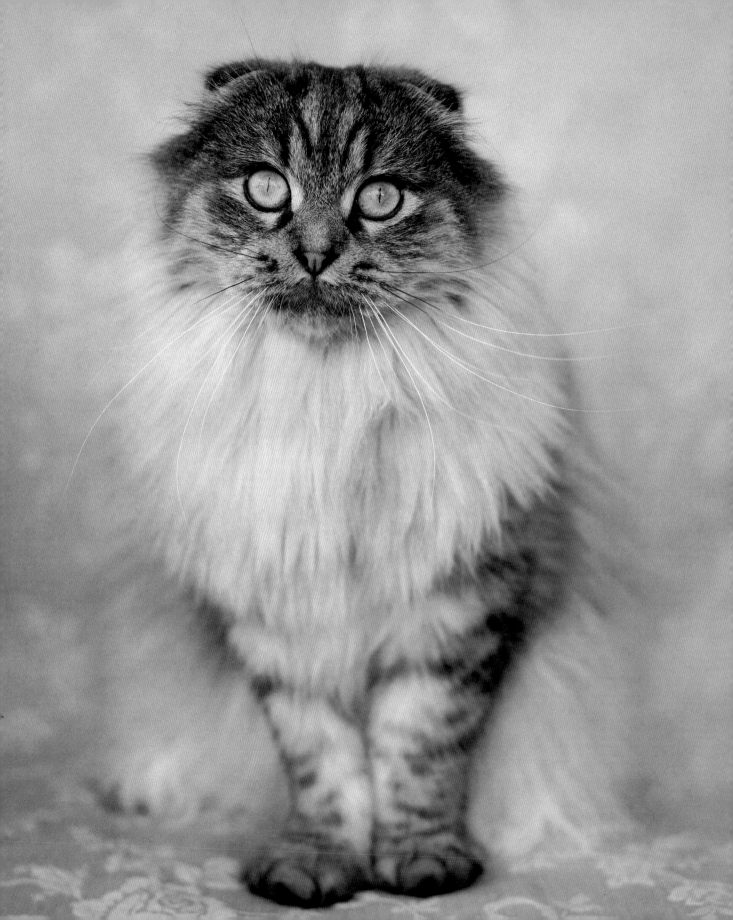

**50. Highland Fold**  Silver Tabby

The dense black markings of the Silver Tabby
Highland Fold's coat are complemented by luxurious
pale silver. Luminous eyes radiate out in green, gold,
or amber.

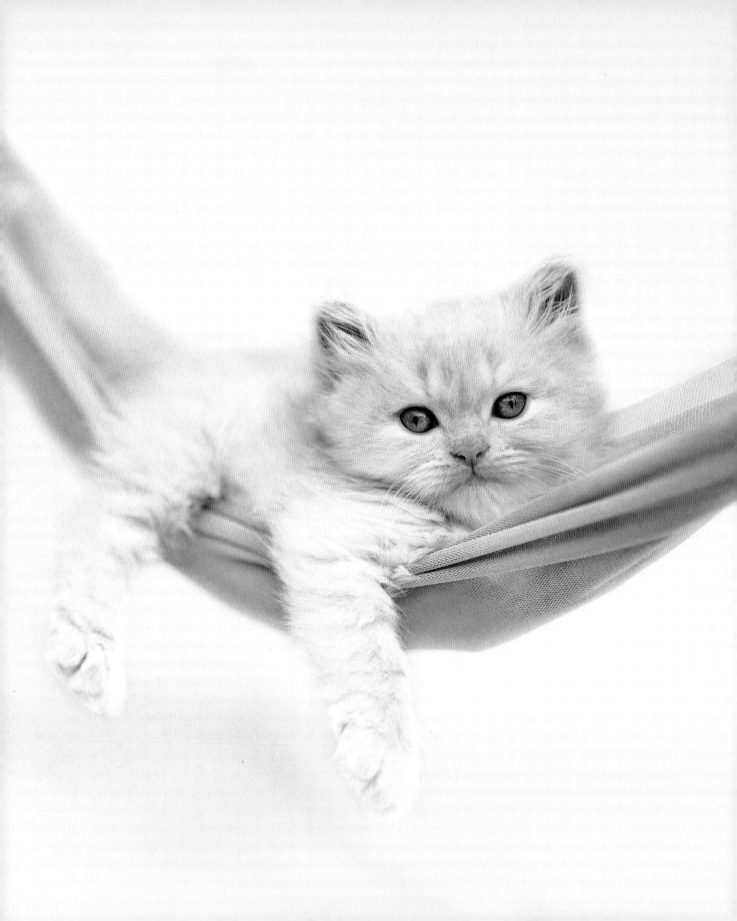

### 51. Highland Variant  Cream

The sweet and friendly Highland Variant is a member of the Scottish Fold family and is an easygoing, low-maintenance, and handsome breed. The Scottish Fold, which was discovered in 1961 in Scotland, has a unique appearance with its folded ears. However, not all kittens born to a litter will carry the folded-ear gene. Those kittens with a long-haired coat whose ears remain straight are then called Highland Variant. Extremely laid-back, the Highland Variant is considered to be the calmest breed in the cat world and a great companion cat for a family with young children and other pets. Affectionate and social, the Highland Variant enjoys nothing better than being with its human family, especially curled up on a lap.

*Appearance: The Highland Variant has a plush medium-to-long coat and a full and luxurious tail that ends in a plume. A full ruff almost covers the ears but sits shorter on the round head and gives the breed a sweet appearance that is enhanced by large round eyes.*

*Color: The Highland Variant can appear in all colors and patterns.*

## 52. Japanese Bobtail Longhair  Black and White

The elegant, soft, and silky long-haired version of
the Japanese Bobtail is a natural development
of the ancient breed. The Japanese Bobtail Longhair
is believed to have also existed for centuries and
was particularly present in the northern provinces of
Japan. And, like the short-haired variety, the Japanese
Bobtail Longhair was a popular subject often depicted
in paintings, including a famous 15th-century painting
of two of the cats showing their long coats parted
neatly down the back. Like so many natural breed
offshoots, the long-haired variety was not embraced
initially as a potential new breed, and it was not until
the mid-1950s that it gained favor, eventually being
acknowledged as a separate breed by TICA in 1991.
The Japanese Bobtail Longhair is a sociable and easy-
going breed. Affectionate, intelligent, and playful, this
beautiful cat makes a loving family member.

*Appearance: The Japanese Bobtail Longhair is a
medium-sized cat with a medium-long-to-long soft
and silky coat, and the signature short "pompom"
thick and fluffy tail. A triangular-shaped head is set
high with large ears and large oval eyes.*

*Color: The Japanese Bobtail Longhair appears in
numerous color and pattern combinations with the
most popular being the tricolor combination of black,
red, and white (Mi-ke).*

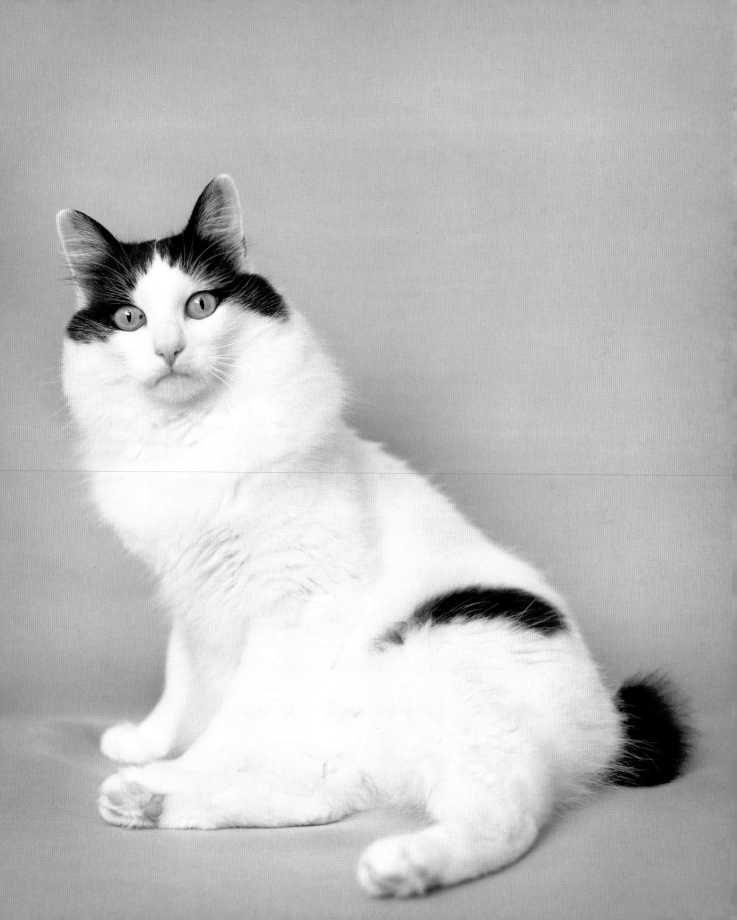

## 53. LaPerm  Chocolate Ticked Tabby

A curly-haired beauty, the LaPerm is a modern breed with a great combination of looks and personality. Discovered as an isolated natural mutation among a typical short-haired barn litter in Oregon in 1982, the first LaPerm was a single kitten born hairless and slightly smaller and longer than its siblings. Two months later a curly coat began to grow and the kitten was aptly named "Curly" and became the foundation cat of the LaPerm breed. Admired for its happy and easy-going nature, the LaPerm is incredibly loving and affectionate. An active breed, the LaPerm is also quite content to curl up on its owner's lap. Known also to be very tactile, the LaPerm enjoys rubbing its face and paws against its human companions making it a very gentle and soothing pet.

*Appearance: The attractive and shaggy coat of the LaPerm can be long- or short-haired, and covers a small but well-balanced body with long legs. The characteristic long neck carries a rounded modified wedge head with large almond-shaped eyes.*

*Color: The LaPerm can appear in any color or pattern. The ticked tabby pattern comprises body hairs ticked in various shades and colors (lighter at the roots, darker at the tips) with no noticeable display of tabby patterning except on the face, neck, legs, tail, and belly.*

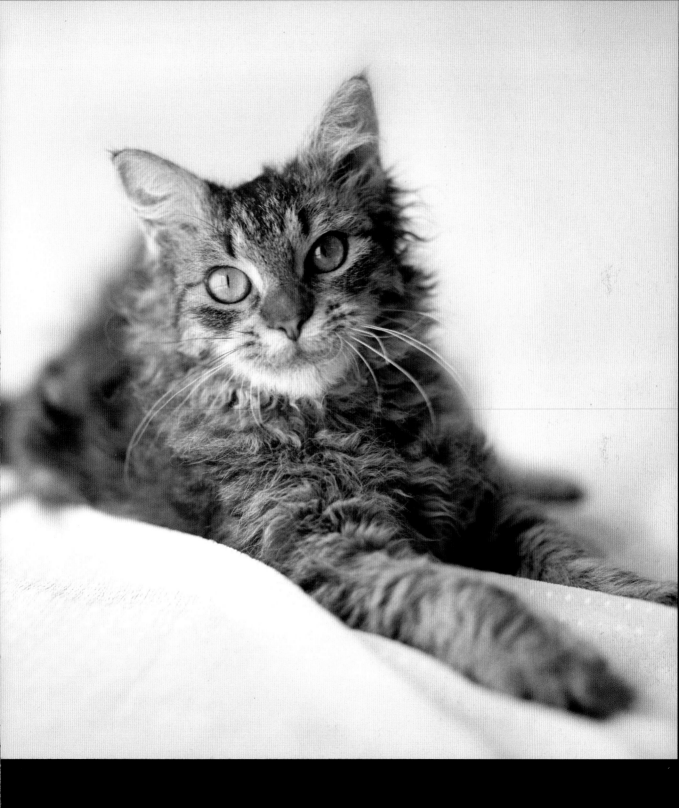

## 54. LaPerm  Black

The Black LaPerm is a solid block of dense color
showing from the roots to the tips of the coat and
flowing onto the nose and paw leather. The only
additional splash of color comes from the eyes,
which glow in contrast to the jet black coat.

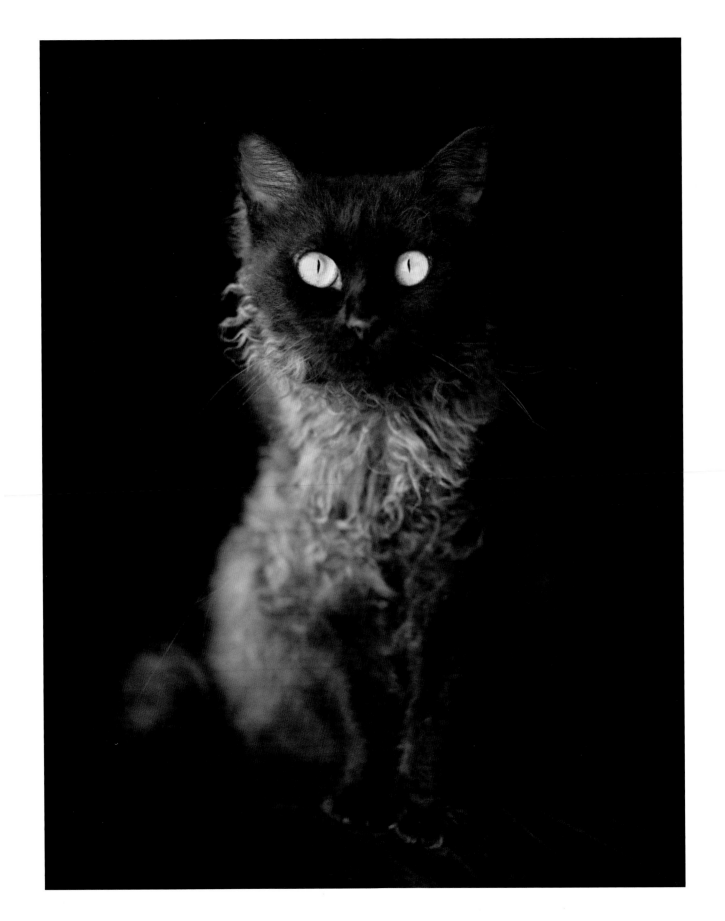

Cat people are different, to the
extent that they generally are
not conformists. How could they be,
with a cat running their lives?

LOUIS J. CAMUTI

**55. LaPerm**  Silver

The radiant silver or chinchilla patterned LaPerm
has a striking pure white ground color that on
the back, flanks, head, and tail is tipped in black.
The overall effect gives the Silver LaPerm a
sparkling quality.

## 56. Maine Coon  Blue

Dignified and handsome, the Maine Coon is the oldest true American breed. A big hardy farm cat suited to varied seasons and environments, it is renowned for its working and hunting abilities. The Maine Coon was brought to Maine by European traders and sailors during the 1800s where the tabby-type cat was often compared to the raccoon. The Maine Coon is recorded to be the very first cat shown competitively in the earliest known cat shows run by the New England farmers during the 1860s. A quirky characteristic is its love of "sleeping rough": it can be found curled up in the strangest positions in the oddest of places. Intelligent and sweet natured, the large Maine Coon is gentle and typically easygoing.

*Appearance: Well-muscled and powerful, the Maine Coon is a physically handsome breed. Long and large, it has a thick, shaggy, yet silky coat, as well as a magnificent luxuriant tail that is as long as the body. The head is small in proportion to the body with large confident eyes and huge ears.*

*Color: The Maine Coon appears in all colors and color combinations except chocolate, lilac, or Siamese type. The Blue Maine Coon should appear as one even color of gray-blue, from the tip of the tail to nose, with even the nose leather and paw pads appearing blue.*

**57. Maine Coon** Tabby

The Maine Coon Tabby can come in either a classic
or mackerel pattern with both displaying the intricate
"M" forehead marking.

### 58. Maine Coon  Silver Tabby

The handsome Silver Tabby Maine Coon can appear in either classic or mackerel patterning, which is made up of striking dense black markings against an icy silver ground color along with patches of cream and/or red.

Who among us hasn't envied
a cat's ability to ignore the cares of
daily life and to relax completely?

KAREN BRADEMEYER

**59. Maine Coon**  Red Tabby

The warm red markings of the Red Tabby Maine Coon,
which can be either classic or mackerel, should be
rich and clear and evenly spread over a red ground
color. The red of the nose leather and paw pads can
be subtly highlighted by a trim of white.

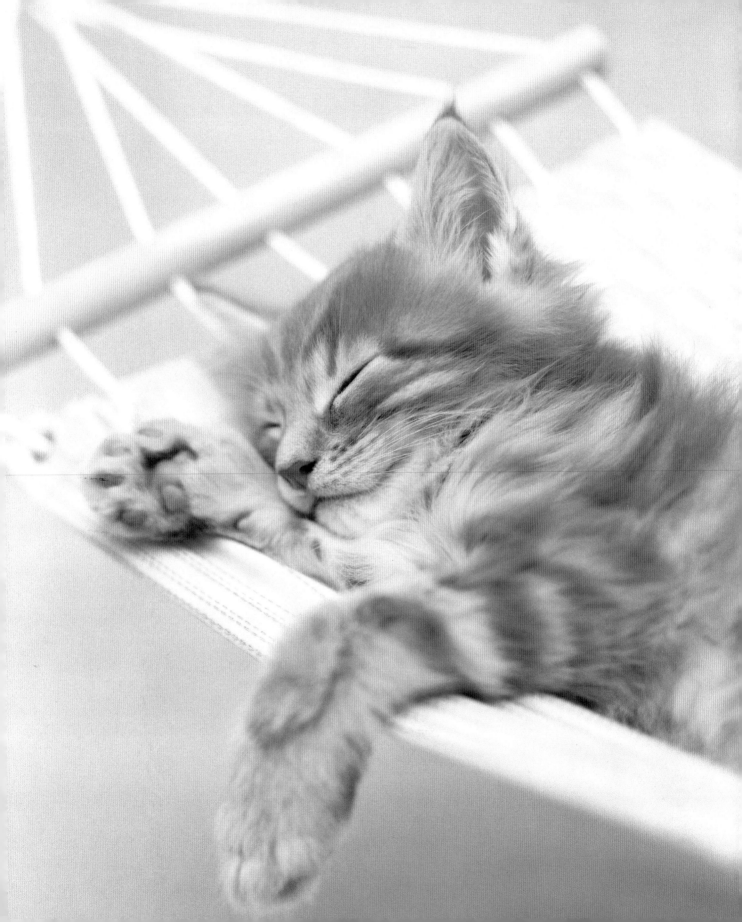

## 60. Maine Coon  Tabby and White

The Tabby and White Maine Coon may show in any
tabby pattern of silver, brown, blue, red, or cream,
but has the added flourish of being dipped in white
on the paws and brushed with white over the bib
and belly.

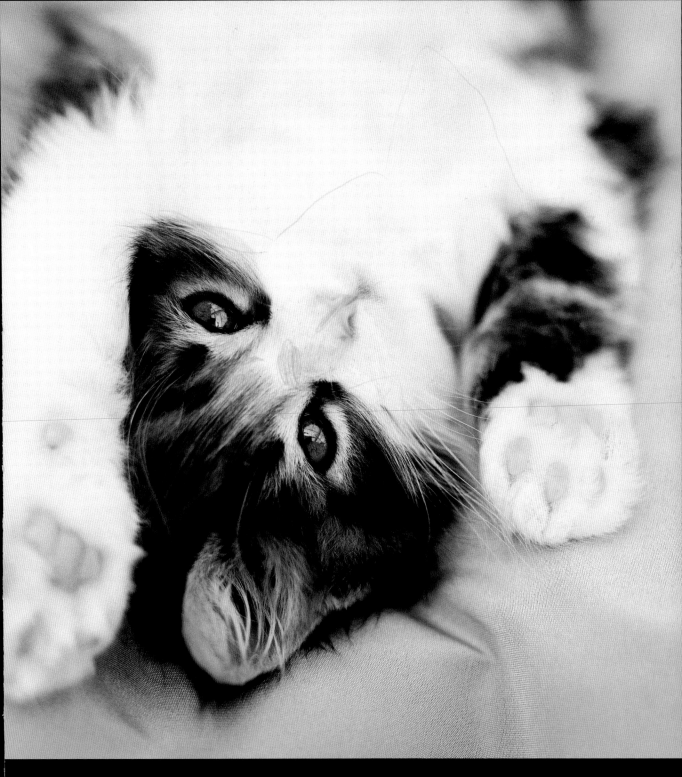

## 61. Norwegian Forest  Golden

A breed of great antiquity, the Norwegian Forest Cat, known as "Norsk Skaukatt" in its native Norway, is also affectionately called the "Viking Cat." Believed to have traveled the world with the Vikings, the cat's fame is well recorded. Norse mythology describes a huge cat that even the god Thor could not lift and that accompanied the goddess of love and fertility, Freya, leading her carriage across the sky. Norwegian folk tales dating between 1837 and 1852 also speak of the breed. A brave and strong farm cat, perfectly designed with an all-weather coat, the Norwegian Forest Cat is a celebrated hunter and skilled tree climber. Essentially an outdoor cat, the breed will not shy away from the comfort of home, however. Affectionate, friendly, and playful, the Norwegian Forest Cat makes for a fun and active companion.

*Appearance: Similar in size to the Maine Coon, the giant Norwegian Forest Cat is muscular and robust with a distinctive bushy tail and double coat that thickens in winter. The outer coat is long and water resistant while the undercoat is thick, providing excellent protection against the cold. Intelligent almond eyes are set wide apart on a triangular-shaped head. Its legs are powerful and long.*

*Color: The Norwegian Forest Cat comes in all colors and patterns.*

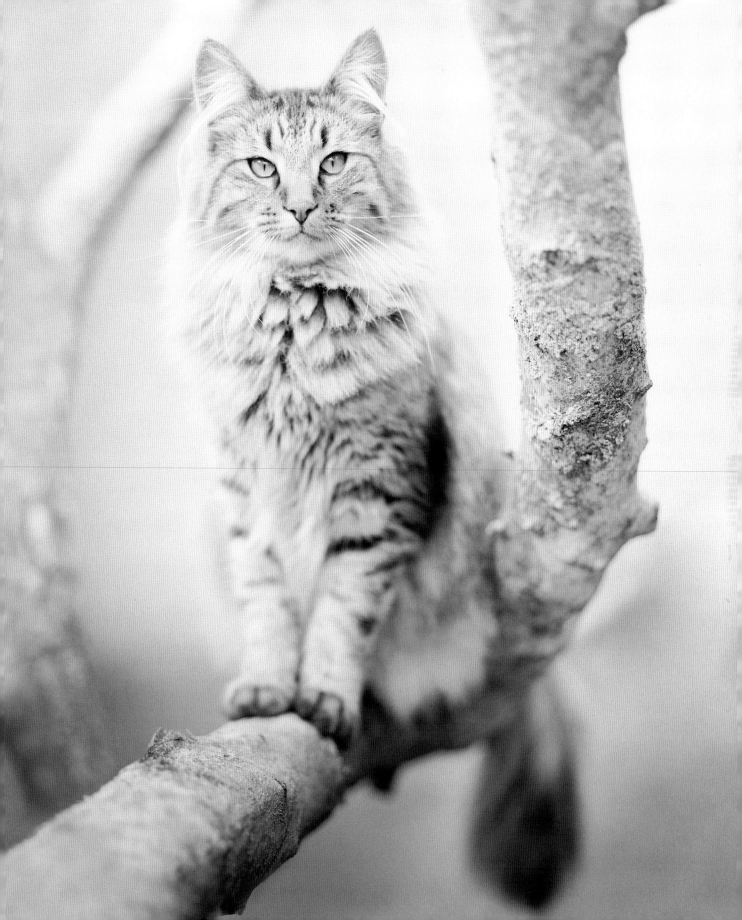

## 62. Ragdoll  Blue and Cream Point

The delightful Ragdoll acquired its name from its unusual habit of going floppy, like a ragdoll, when picked up. A large breed developed in the United States during the 1960s from a mating between a white Persian-style cat and a Birman male, the Ragdoll is famous for its extremely placid and affectionate nature. The continued quality and refinement of the breed has seen the Ragdoll eventually become widely accepted, and its good looks and personable nature have guaranteed a large following. So well admired was the breed that in the 1990s three variants of the Ragdoll were attempted: the Honeybear, the Cherubim, and the Ragamuffin, of which the Ragamuffin is proving to be successful. The Ragdoll is the most docile of all cat breeds and loves human companionship, greeting its owners at the door and loyally following them about the home.

*Appearance: A large, semilong-haired breed, the Ragdoll is a beautiful combination of dark points and a lighter body color, with captivating blue eyes. The broad head of a modified wedge shape with a round muzzle and chin is offset by a plush and silky coat and full bushy tail.*

*Color: The Ragdoll comes in three basic pattern-types: colorpoint, mitted, and bicolor. It also comes in four colors: seal, blue, chocolate, and lilac. The most popular of the Ragdoll varieties is the Colorpoint Ragdoll. The coat comprises a light-shaded body color contrasting against well-defined points of ears, mask, legs, and tail, with no white allowed. The overall effect is a pure harmony of color.*

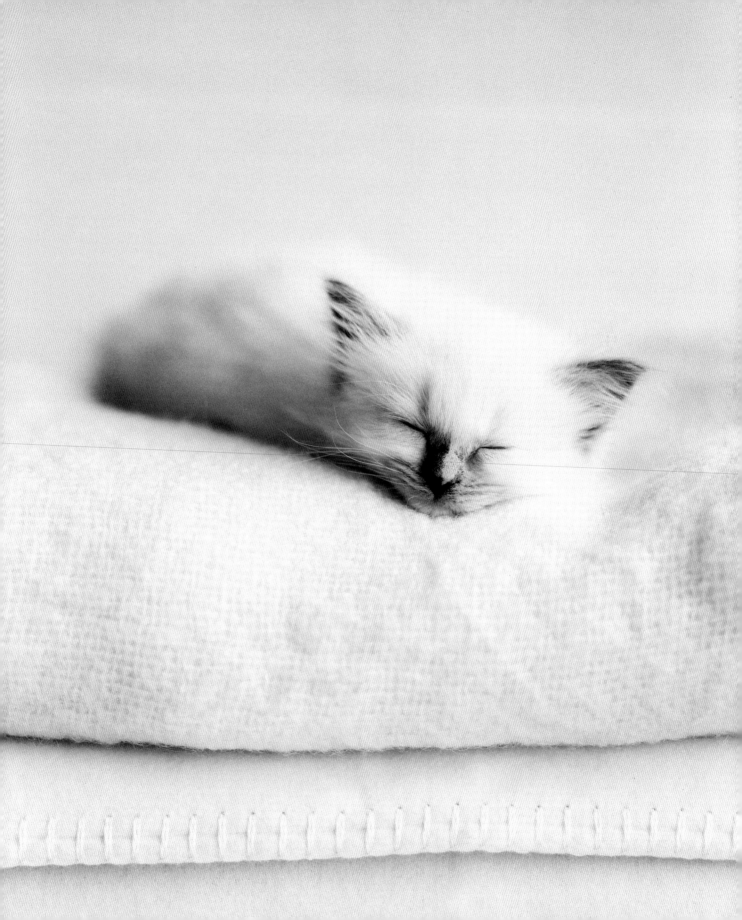

A cat determined not to be found can fold itself up
like a pocket handkerchief if it wants to.

LOUIS J. CAMUTI

**63. Ragdoll**  Blue Bicolor

The accents of blue on the Blue Bicolor Ragdoll
create an appearance of adorable style and luxury,
which is further enhanced by its exquisite blue eyes.

## 64. Ragdoll  Seal Bicolor

The Bicolor Ragdoll is a striking and surprising
mix of colorpoint and white. The body is light in
color with the points—ears, mask, and tail—all well
defined by the signature color, in this example seal.
The bib, chest, and belly should be white, as should
the front and back legs, but ideally no white should
appear on the points. A defining feature of a champi-
onship Bicolor Ragdoll is a white inverted "V" that
starts from the forehead and extends down to cover
the nose.

## 65. Somali  Ruddy

The handsome Somali, often called the "little fox cat," is a long-haired version of the Abyssinian. During the 1950s, long-haired kittens appeared in short-haired Abyssinian litters, but were originally disregarded as a new breed. However, the striking beauty of the cat once fully matured soon won over American breeder Evelyn Mague, who led the charge to develop the Somali as a breed in itself, and eventually had the honor of naming it. Evelyn Mague's male cat "George" is considered the breed's "founding father." Often described as a "wild-looking" cat, the Somali, though not wild, is indeed a lively breed. It loves to play and socialize, thriving on human company and interaction. Extremely intelligent, the Somali will make the most of its environment: learning to turn on and off a faucet, play with water, and open and close doors to find a good hiding spot. This lively personality, along with the Somali's fine looks, produces an engaging breed.

*Appearance: The Somali is a medium-to-large breed. Athletic and muscular, it is covered by a soft and silky coat that appears fuller on the ruff and billows thickly at the tail.*

*Color: The four recognized colors of the Somali are ruddy, sorrel/red, blue, and fawn. The Ruddy Somali (also referred to as "usual" in the United Kingdom) is one of the most commonly bred varieties. The glowing coat is a golden color with darker brown or black ticking.*

Prowling his own quiet backyard

or asleep by the fire, he is still

only a whisker away from the wilds.

JEAN BURDEN

**66. Somali** Fawn

The soft appearance of the Fawn Somali is due to
the warm pinkish beige ground color ticked by
cocoa brown at the very tips of the hairs.

**67. Somali**  Sorrel

The warm and glowing Red Somali (also known as
"Sorrel Somali") is one of the two most commonly
bred varieties of Somali, the other being the ruddy
variety. The rich copper-red ground color is
accentuated by chocolate brown ticking that
darkens at the ends.

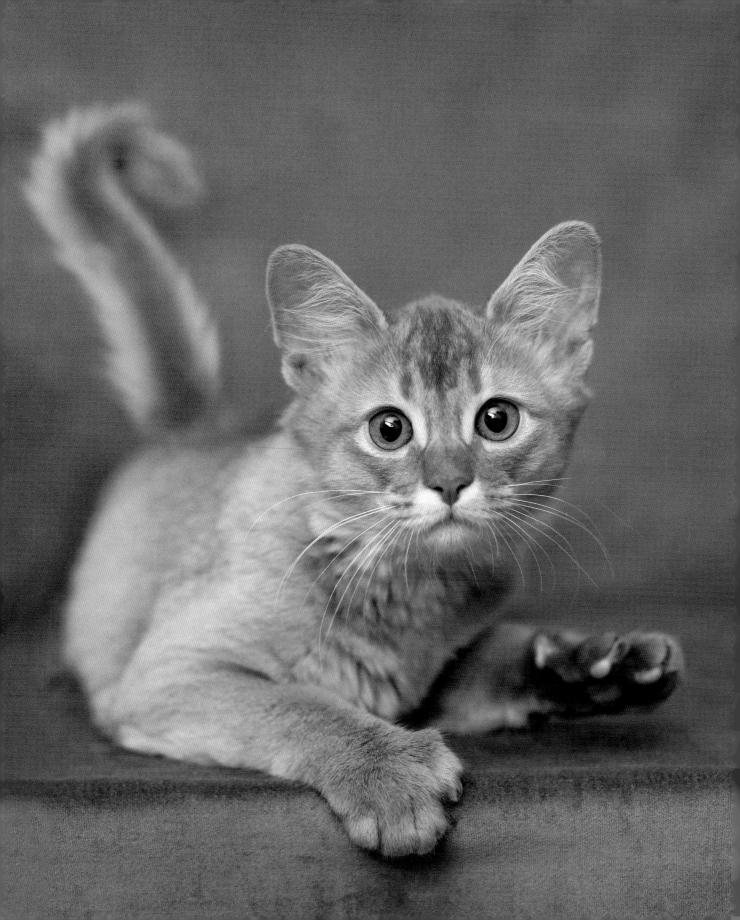

## 68. Turkish Van  Red and White

The water-loving Turkish Van is called "Van Kedi" in its country of origin, Turkey, and is fondly referred to as the "Swimming Cat." An ancient breed, the cat comes from Turkey's Lake Van region close to Mount Ararat, the legendary site of the landing of Noah's ark. Local legend speaks of how when the ark came to rest and the resident cats left its protection and descended the mountain, they were touched and blessed by Allah, turning a patch of their coat auburn. The striking Turkish Van is certainly a breed of great antiquity and has been highly valued and well protected locally, not being discovered outside Turkey until the mid-1950s. The affectionate breed has an unusual love of water and its beautiful appearance and colorful personality make it easy to fall in love with. Intelligent and strongly independent, the Turkish Van enjoys freedom to roam and play outside and to come and go as it pleases.

*Appearance: Powerful and muscular, the Turkish Van is both strong and agile. Its striking water-resistant long and silky coat is beautifully marked on the far reaches of the forehead and tail, exaggerating its long body.*

*Color: The most popular color combination is white and auburn, but the head and tail marking can appear in all traditional colors.*

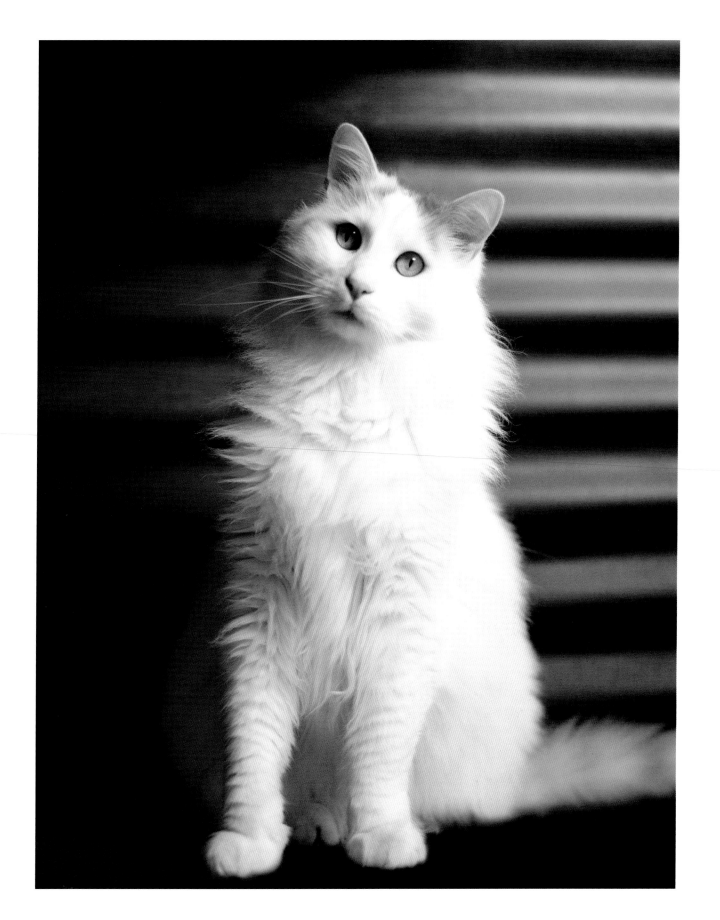

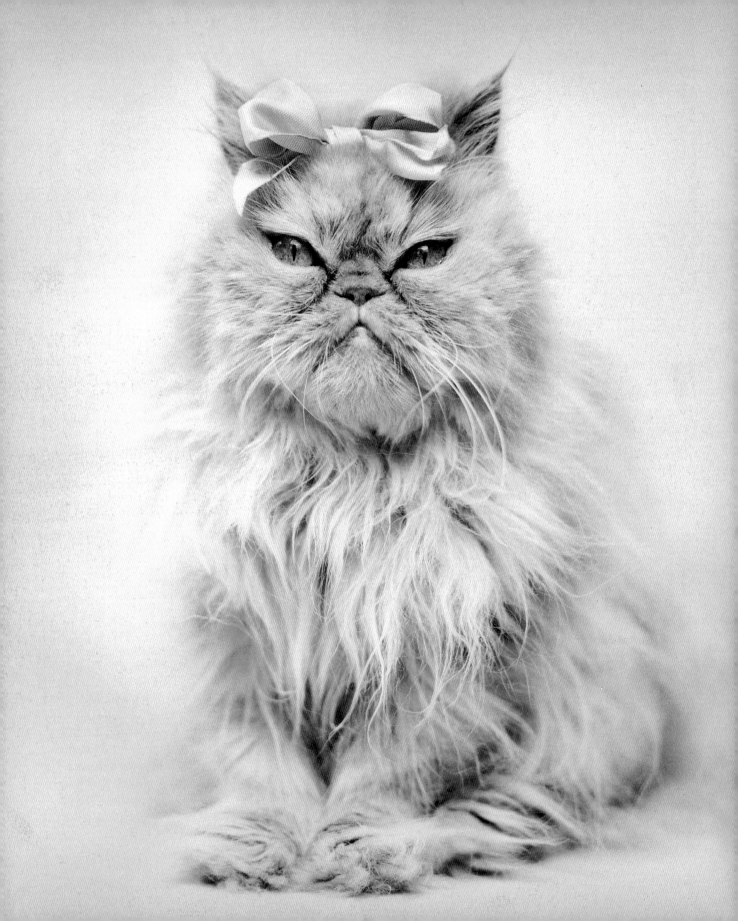

Longhair

### 69. Chinchilla Persian  Silver Shaded

The exquisite and glamorous Chinchilla Persian is named, surprisingly, after the South American chinchilla rodent because it shares the same coat characteristics. However, unlike the rodent's silvery-gray coat that comprises a dark undercoat tipped in white, the Chinchilla Persian wears the reverse, establishing its celebrated sparkling appearance. Considered one of the earliest man-made varieties of cat, the first Chinchilla class was established in 1894 at Crystal Palace, and in 1901 the first Chinchilla club in Britain was founded. Originally much darker than the modern equivalent, the Chinchilla is believed to be the result of crossbreeding of a range of longhairs, in particular Silver Tabbies. Regarded to be slightly more temperamental than other Persians, the Chinchilla is typically attentive and loving toward its human companions.

*Appearance: Considered by many to be the most glamorous of the Persians, the Chinchilla is slightly more delicate with a finer bone structure than other typically cobby-bodied (compact and heavyset) Persians. Emerald green or blue-green eyes are rimmed in black or brown.*

*Color: Sparkling snow-white with black tipping scattered evenly and ever so lightly through the face, legs, tail, and body.*

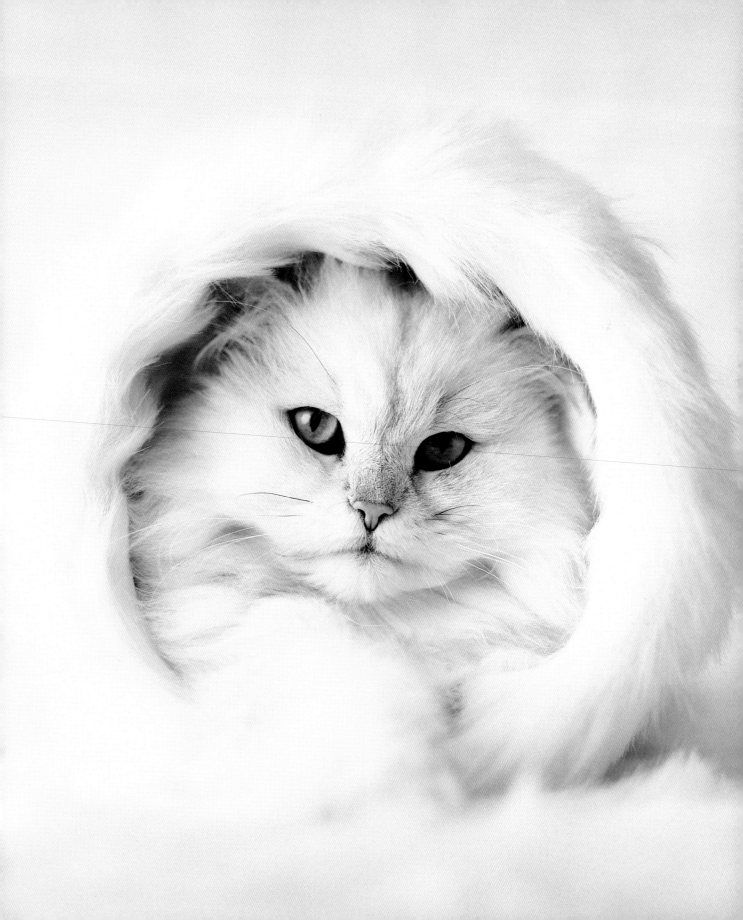

## 70. Persian  Chocolate

Dignified and sweet natured, the Persian is considered to be the oldest cat breed. Hieroglyphic depictions of a long-haired cat lead some to believe it has been around since as early as 1684 BC. Named after what is regarded its country of origin, Persia, it was during the 16th century that the cat made its way to Europe. The signature long, thick flowing coat and large expressive eyes made the Persian extremely popular and highly valuable. An established breeding program has produced an astonishing array of colors that has resulted in seven divisions for purposes of competition. A natural model, the Persian's love of posing has seen it become the photographer's darling. Tremendously responsive, social, and playful, the Persian is a loving companion, enjoying the company of other animals and humans.

*Appearance: The Persian is a large, strong cat with a cobby body supported by low sturdy legs. The coat is sumptuously long and flowing, covering the entire body, with an immense ruff around the head. Extremely large, round, and expressive eyes are set wide above a flat nose and full cheeks.*

*Color: A contemporary Persian color, the Chocolate Persian is a picture of warmth and richness. An opulent chocolate brown covers the entire body from the roots to the tips of the fur and nose leather. A hint of cinnamon pink on the paw pads together with the brilliant copper eyes adds a pleasant touch of contrast to the chocolate palette.*

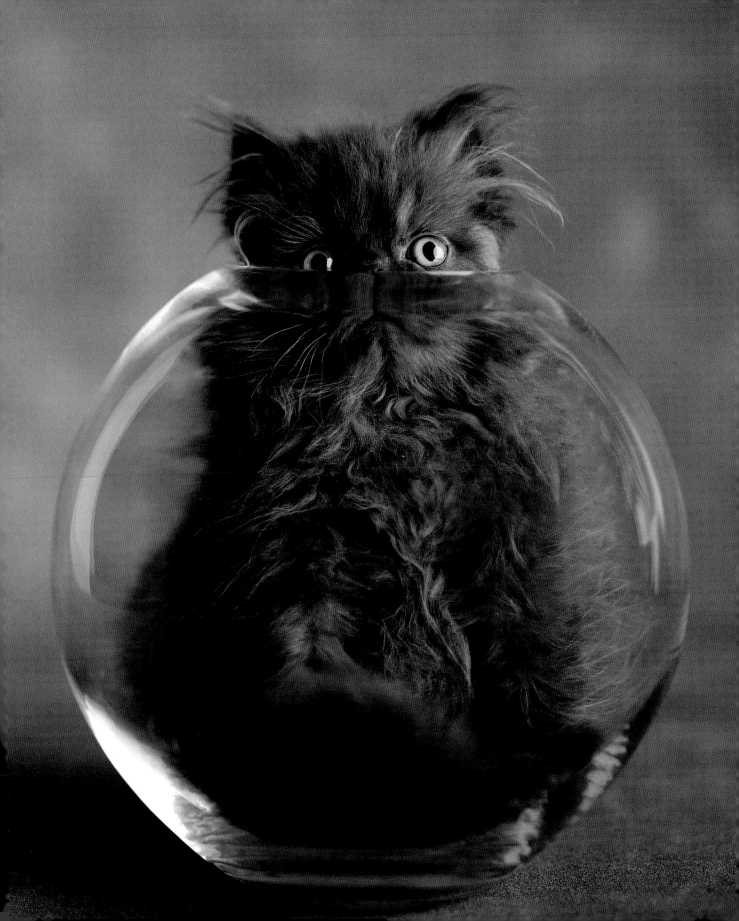

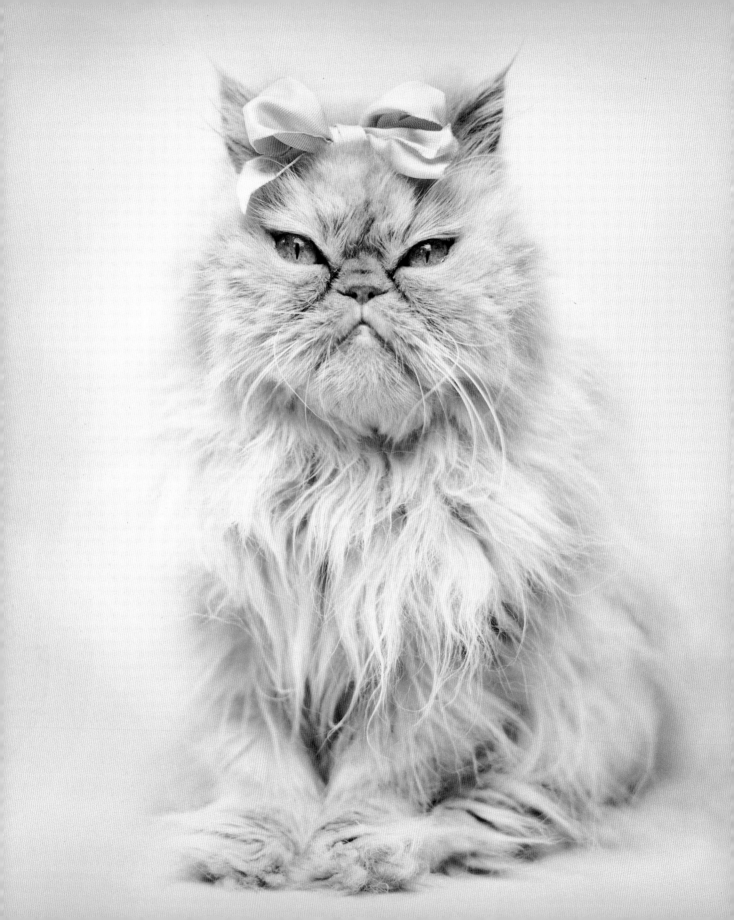

## 71. Persian  Red Self

The striking Red Persian is considered one of the rarest of the Persian family. Originally called "orange," the variety was first shown in Britain as early as 1895. Today, however, fine examples of Red Persians are scarce due to the breed being extremely hard to produce to show standards that require a high quality of color soundness. It is more common to see most Red Persians with some tabby markings. It is also extremely common that within one litter there may appear both pure red and red tabby kittens. In addition, the development of the breed was hindered during World War Two when the largest known group of top Red Persians was destroyed. Like all Persians, the Red Persian is most happy posing and being decorative. The Red Persian maintains the pleasant, polite, and friendly nature that the breed is known for, making it a perfect companion, and, like anything rare, highly treasured.

*Appearance: On a solid cobby body, the Red Persian's coat is silky and lush. Brilliant copper-colored eyes are round and large set on a broad, round head.*

*Color: The Red Persian should have a deep orange-red coat. Nose and feet pads should be a brick-red color.*

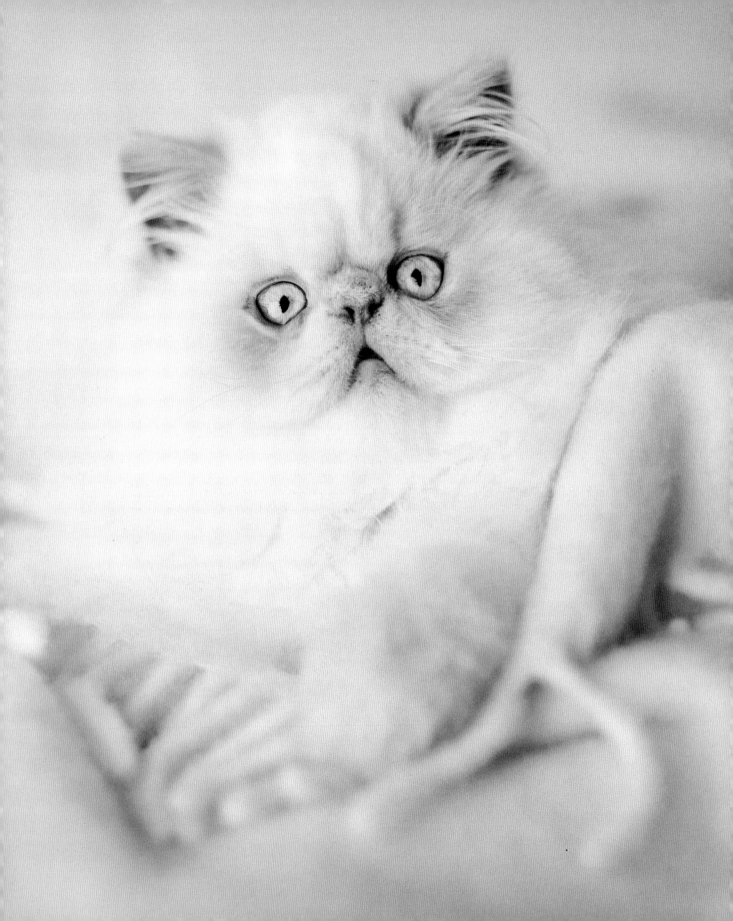

### 72. Himalayan Persian Cream Point

Affectionately nicknamed "Himmy," the attractive Himalayan Persian is a combination Persian and Siamese, and is officially called the Colorpoint Longhair in England. During the 1920s and 1930s, breeders from several countries wanted to create a complete Persian type with the striking coat markings of the Siamese (while taking nothing else from this breed). The breeding process was a complex and difficult journey and it took several years until both England and the United States had produced true Himalayan kittens. Almost 30 years after the birth of the concept, the Himalayan Persian was officially recognized in England in 1955 and two years later in the United States. The Himalayan is completely Persian in personality, a true "lounger," loving to drape itself over furniture or lie on a welcoming lap. Being very people-oriented, the cat loves to be involved in the goings-on of the household.

*Appearance: The Himalayan Persian retains all the Persian physical characteristics except for its signature colorpoint coat pattern taken from the Siamese.*

*Color: Originally only recognized in seal, blue, chocolate, or lilac point, today the Himalayan Persian also presents in flame, tortoiseshell, lynx, blue-cream, and cream points.*

A cat is more intelligent than people believe,

and can be taught any crime.

MARK TWAIN

**73. Persian** Lilac

The thick silky coat of the Lilac Persian is warm and
even in tone. The brilliant copper or deep orange
eyes are rimmed in lilac and blend beautifully with
the warm lavender coat with its pinkish shimmer.

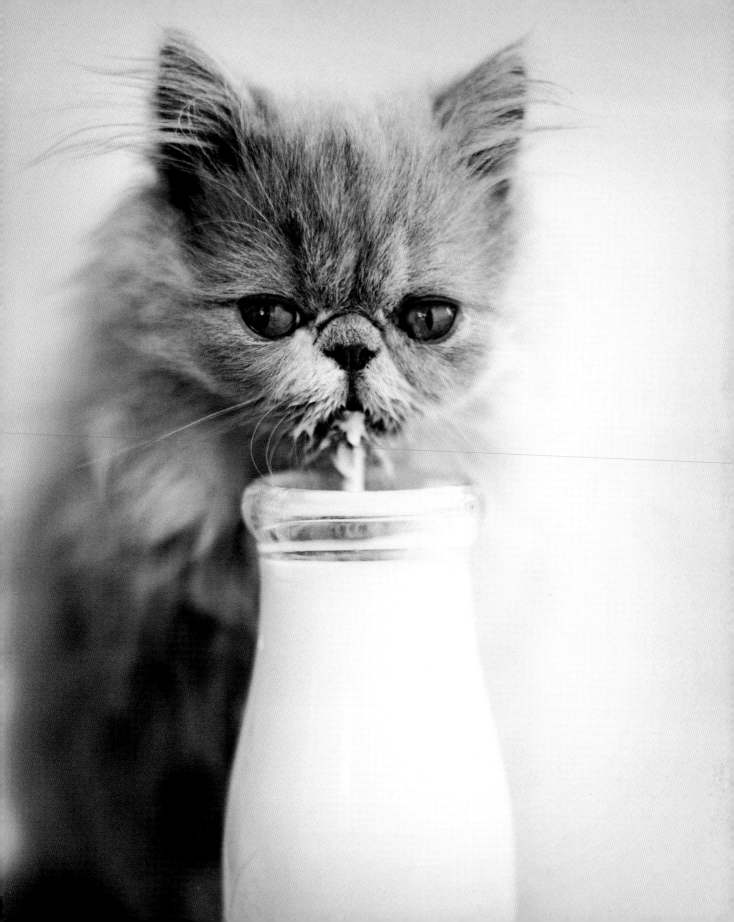

**74. Persian**  Brown Tabby

The Brown or Chocolate Tabby Persian can appear in the classic or mackerel pattern and is a beautiful display of rich, warm colors. The warm milk brown of the ground color is highlighted by the rich dark brown of the tabby markings.

### 75. **Persian**  Chocolate Point

The regal Chocolate Point Persian or Chocolate Himalayan, a mix of ivory on the body with chocolate points, demands attention with its piercing blue eyes framed dramatically by the dark chocolate colorpoint.

Asian

### 76. Asian Shorthair  Black Tipped Tabby

The inquisitive and extroverted Asian Shorthair is typically recognized not as a single breed but as a group of four—shaded (Burmilla), smoke, self, and tortoiseshell—and tabby with the semilong-haired variety, the Tiffanie, an offshoot of the group. The Asian Shorthair was developed in Britain during the 1980s after an accidental mating of a European Burmese and a Chinchilla Persian. The owner of the cats, Miranda von Kirchberg, recognized their value immediately and set about establishing a breeding program. By 1989 the Shaded Asian Shorthair had been officially recognized by the Governing Council of the Cat Fancy in Britain and soon thereafter the other Asians followed suit. The Asian Shorthair has a charming personality: it is incredibly relaxed and gentle, yet a born entertainer. Having an extremely good temperament, the Asian Shorthair makes a perfect family pet.

*Appearance: Exceptionally striking, lithe, and muscular, the Asian Shorthair is a medium-sized cat with a short coat. The female is significantly smaller and daintier than her male counterpart.*

*Color: The Asian Shorthair comes in a vast array of colors and patterns. The Tabby Asian Shorthair, developed in the second generation of crosses, appears in all four tabby patterns: ticked, spotted, classic, and mackerel.*

## 77. Bombay  Black

Sleek and elegant, the Bombay is the panther of
the cat world—aptly named after the Indian black
leopard. An American-designed cat, the breed was
intentionally developed in 1958 by Nikki Horner
from Louisville who desired a domestic miniature
black panther. She selected an American Shorthair
male for its solid rich black coat and deep copper
eye color to cross with a grand champion Sable
Burmese female for its beautiful coat sheen. The
successful combination resulted in the establishment
of a new breed that gained championship status in
the United States in 1976. Still rarely seen outside
the United States, the Bombay with its handsome
panther qualities is an intelligent and extremely
affectionate breed that craves attention and loves
to snuggle in close to its owner. Also known to
be playful, inquisitive, and patient, the Bombay
can easily be trained and thoroughly enjoys
engaging in games.

*Appearance: Medium and compact, the Bombay is
a short-haired cat with a satinlike sheen to its signature
black coat. Large and round, the striking copper-
colored eyes add to the pantherlike appearance
of the Bombay.*

*Color: Black.*

### 78. Burmilla  Silver Tabby

Even-tempered and intelligent, the Burmilla is an elegant, medium-sized cat. A modern breed, it is the result of an accidental mating between a Lilac Burmese female and a Chinchilla Silver male in 1981 in Great Britain. The outcome of this mating was four black-shaded silver female kittens with lovely temperaments and short dense coats that caused a great stir in the cat world. Soon a comprehensive breeding program was established and in 1983 the Burmilla Cat Club was founded. The Burmilla's personality is a well-balanced combination of the Burmese and the Chinchilla. Similar to the Burmese, the breed is playful and sociable, while it retains the laid-back qualities of the Chinchilla. This friendly and good-natured blend makes the Burmilla a perfect family pet.

*Appearance: Medium in length, lithe but muscular, the Burmilla's physique is similar to the Burmese. The impressive sparkling shaded or tipped coat is short, dense, and silky, and is beautifully complemented by large expressive eyes outlined in black. The Burmilla can also carry the Chinchilla long-haired gene.*

*Color: Shaded or tipped in black or any of the Burmese colors, the Burmilla has a silver or golden base color.*

### 79. Tiffanie  Brown Tabby

The friendly and beautiful Tiffanie combines the body type and coloring of a Burmese with a long silky coat. Frequently confused with the American Tiffany or Chantilly cat, the Tiffanie originated in Britain, coming from the Burmilla breeding program (Burmese crossed with Chinchilla). Among the offspring of these unions would occasionally appear kittens carrying the long-haired gene of the Chinchilla, which eventually led to a separate breeding program instigated by British breeder Jeanne Bryson. A member of the Asian cat group, the Tiffanie was originally called the Oriental Longhair. Quieter and less active than its Burmese and Chinchilla relatives, the Tiffanie is highly regarded as an extremely well-behaved breed. Loving and affectionate, the Tiffanie thrives on human companionship but will not fret when left alone.

*Appearance: The characteristic coat is long and silky, and covers a strong body similar in type to the Burmese. The Tiffanie appears in three distinguishable coat patterns of tipped, shaded, and smoke, as opposed to the Burmilla's two.*

*Color: The most popular colors are black, blue, brown, and chocolate, with lilac being less common.*

The idea of calm exists in a sitting cat.

JULES RENARD

## 80. Tiffanie  Chocolate

The striking Chocolate Tiffanie's handsome coat has a
warm caramel-toned ground color and full ruff, with
dark cocoa shades defining the points and drawing
attention to the icy blue eyes.

## 81. Tiffanie  Seal Smoke

The enchanting smoke coat pattern seems to magically change color as the cat moves. As each hair is pale at the root gradually darkening to the tip, the Seal Smoke Tiffanie will appear chocolate when stationary, but in motion the pale undercoat is exposed, tempering the brown tone.

## 82. Tiffanie  Silver Shaded

On the elegant and beautiful long silky coat of the
Silver Shaded Tiffanie, each individual hair is silvery
gray with a black tip. The overall effect is a pale
gray coat that shimmers, producing a soft and
ethereal look.

Oriental

### 83. Balinese  Fawn Point

The attractive and dainty Balinese is a pointed semilong-haired version of the Siamese. Named after the exotic dancers of Bali, the cat's natural elegance stems from its Siamese origins. The breed emerged during the late 1940s in the United States from a natural mutation of the Siamese, and 30 years later was awarded championship status. Long and slender in body with the same wedged-shape heads, the standards of the Balinese and Siamese are almost identical except for the length of their coats. Intelligent and alert, the Balinese offers an air of nobility but is essentially a fun-loving, playful, and curious cat. Known to be slightly softer spoken than its Siamese counterpart, the Balinese is a sweet-natured, loyal, and affectionate companion.

*Appearance: The Balinese is similar in appearance to the Siamese: long and svelte in body, legs, and tail. The distinguishing semilong-haired coat is fine and silky, and gives the Balinese a softer appearance. The eyes are a brilliant sapphire blue and the signature tail hair spreads out like a plume.*

*Color: The Fawn Point Balinese has a soft and warm fawn-to-cream body color gradually lightening on the stomach and chest, and is framed by cocoa brown nose leather, paw pads, and points. Other popular Balinese colors are blue point, chocolate point, and lilac point.*

## 84. Balinese  Lilac Point

Commonly referred to as the "glacial-toned"
Balinese, the Lilac Point presents a clean white
coat with frosty gray and pinkish-toned points.
Nose leather and paw pads are lavender-pink
and the eyes a vivid blue.

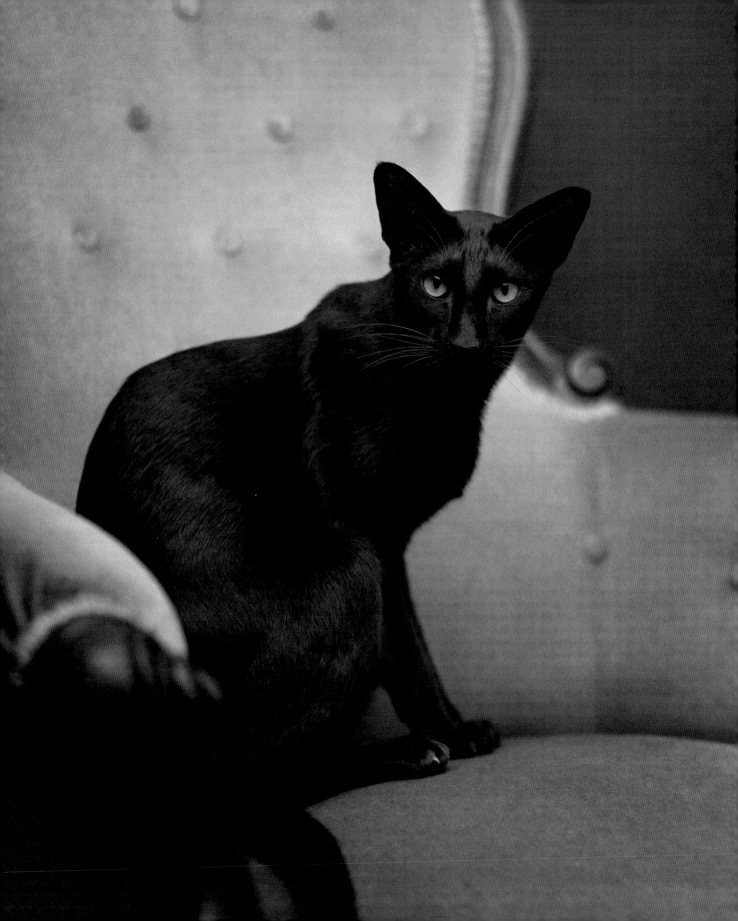

## 85. Havana Brown

Regal and handsome, the Havana did not originate in Cuba as its name suggests but was developed in England during the 1950s. Sometimes referred to as a lucky accident, a brown self male was born to an accidental crossbreeding of a Black Shorthair and a Chocolate Point Siamese. The breeder was quick to realize its value and proceeded with developing the breed. The Havana was first shown in England in 1953 and soon gained championship status in 1958. Imported to the United States in 1956, the American Havana is today closer to the original look with a rounder face and shorter nose than its English counter-part, which is due to repeated back-crossing. Both Havana types are highly intelligent and extremely people-oriented. Sweet natured, the Havana is a charming and gentle breed.

*Appearance: Elegant and graceful, the Havana is a muscular medium-sized breed. Its even-colored, short coat is smooth and glossy, accentuating the fine physique. The Havana's distinct head is slightly longer than it is wide with large, piercing oval green eyes and large ears.*

*Color: Rich chocolate color that can also appear as a lilac—a pale tan with a pinkish tone.*

## 86. Javanese  Black

The elegant Javanese, like its close relatives the
Balinese and Siamese, is a beautiful breed made
up of elongated lines. Although the name Javanese
refers to slightly different types of cats depending
on the region, the breed is essentially a long-haired
Siamese that doesn't conform to the traditional
colors of the Balinese. It was during the 1960s in the
United States when Balinese kittens started to show
unusual color patterns that a separate category was
created. Like the Balinese that takes its name from
the exotic dancers of Bali, the Javanese is named for
the beautiful dancers of the island of Java, though
neither breed originates from either country.
Extremely dynamic and sociable, the Javanese is
a busy cat that loves to follow the activities of the
household. Avidly curious and somewhat fearless,
the breed has a passionate love of high places and
enjoys all types of games.

*Appearance: Take the elegant, lithe, and angular
body of the Siamese, along with its wedge-shaped
head and large blue eyes, add an array of colors
on a luxurious long and silky coat, and you have
the Javanese.*

*Color: In the United States, the cat can appear in any
color of the colorpoint shorthair, while outside the
United States the Javanese colors are linked to the
Oriental Shorthair.*

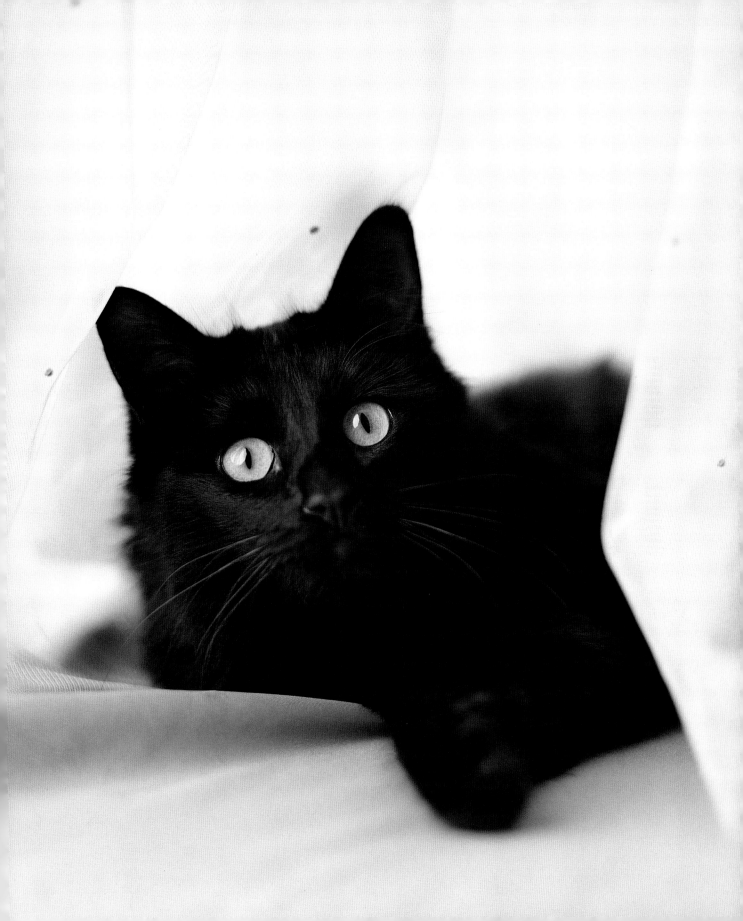

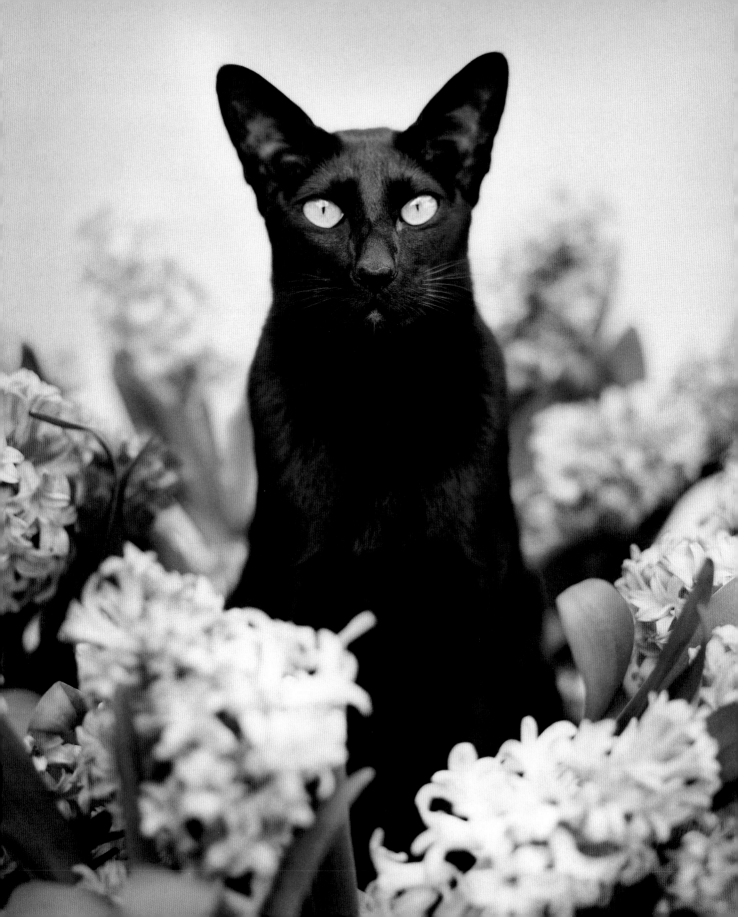

### 87. Oriental Shorthair  Ebony

Extremely elegant, the medium-sized Oriental Shorthair, with a short, close-lying coat, is virtually identical to the Siamese except for having mixed eye colors and no color restrictions. Known for being just as talkative as the Siamese but with a quieter tone, the Oriental Shorthair is also extroverted and inquisitive. A man-made breed first developed in the mid-20th century, the exquisite cat that we see today is the result of a dedicated breeding program. The Oriental Shorthair eventually gained championship status from the CFA in 1977 and rapidly became one of the most admired breeds. This cat loves company and will emphatically snuggle and cuddle up to its owner. Certainly not a cat to be ignored, its energetic, playful, and intelligent temperament make the Oriental Shorthair a passionate and fun companion.

*Appearance: "Long" is the fundamental ingredient of the Oriental Shorthair: the ears are long and pointed, the legs are long and fine, the tail is long and tapered, and the nose is long and straight, all together presenting a sleek and graceful animal.*

*Colors: The Oriental Shorthair has over 300 different color and pattern variations, with the most common colors being black, chocolate, cinnamon, and red. The Black or Ebony Oriental is entirely covered by a dense, pure jet black coat that is offset by magnificent vivid green eyes.*

The cat has nine lives: three for playing,

three for straying, three for staying.

PROVERB

**88. Oriental**  Seal Lynx

The striking tabby markings of the Seal Lynx
Oriental are a rich seal brown on a soft-toned,
fawn-colored body. The term "lynx" refers to
the tabby-patterned point.

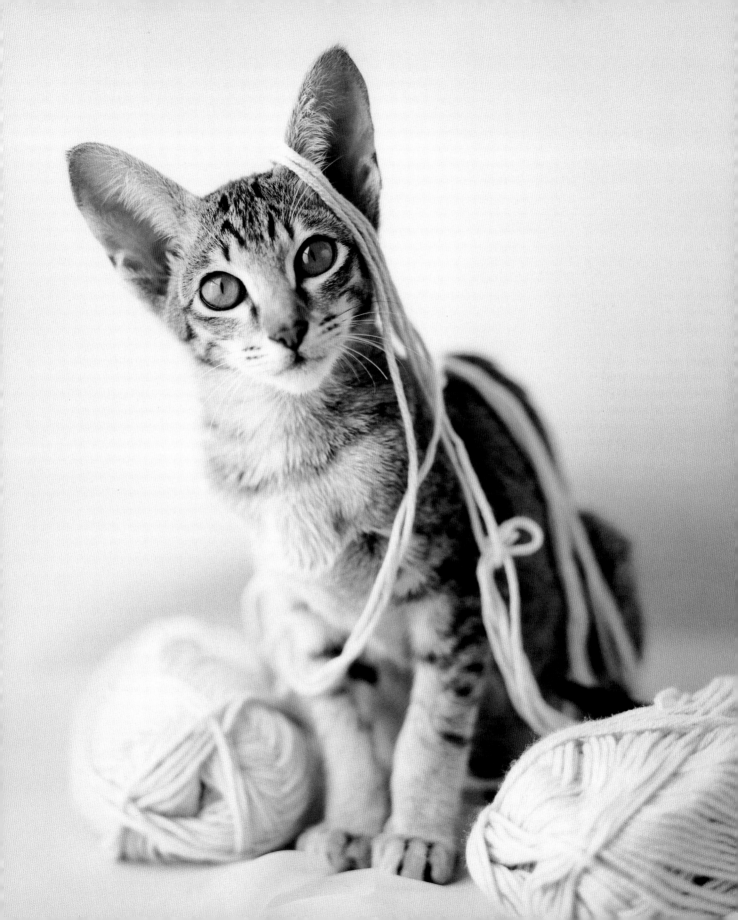

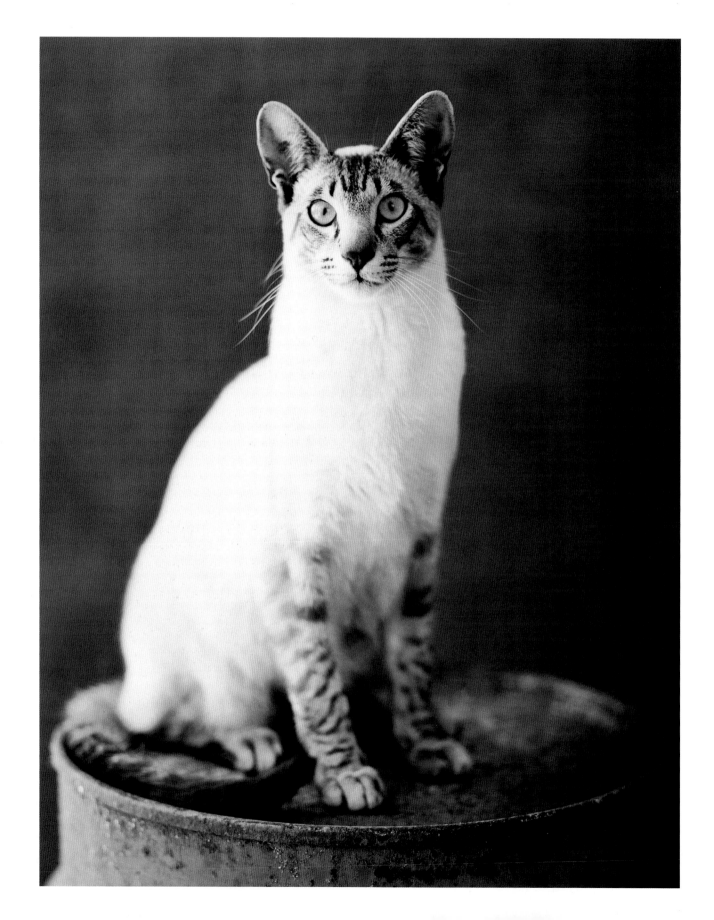

### 89. Siamese  Lynx Point

Sleek and elegant, the aristocratic Siamese radiates intelligence. Considered one of the oldest cat breeds, the cat originates from Siam (now Thailand) and is well documented throughout the art and literature of that country. However the modern Siamese, being much more elongated and angular in body, is quite different to its ancestors first exported to the West. The first Siamese was imported into England during the early 1800s by a returning ambassador from Siam, who had been given one as a gift. Immediately admired, the breed quickly became popular and was defined by the traditional four colorpoints of chocolate, lilac, blue, and seal, as well as the elongated body. Well-admired for its beauty and brains, the Siamese is a typical "people" cat: the breed's extroverted nature and "loud" voice will always get it noticed, while its inquisitive and loving nature wins hearts.

*Appearance: Celebrated for its sleek beauty, the Siamese is all about length: long and elongated body lines are formed by long legs, a long neck, and a long tail. Large pointed ears sit on a wedge-shaped head with deep blue almond-shaped eyes.*

*Color: Lynx point, seal point, blue point, chocolate point, and lilac point.*

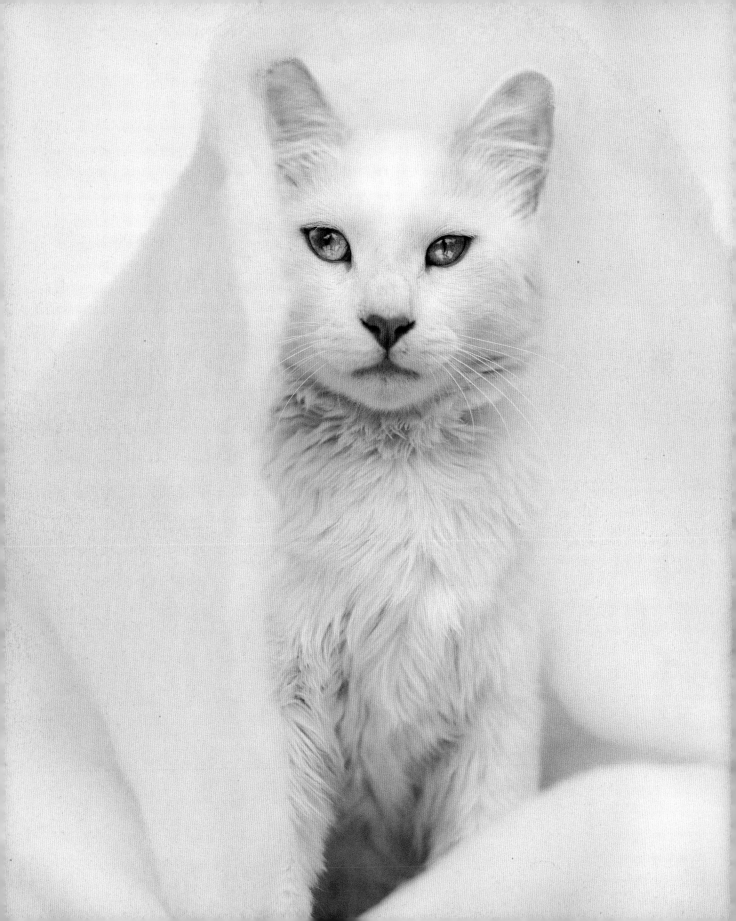

# Miscellaneous

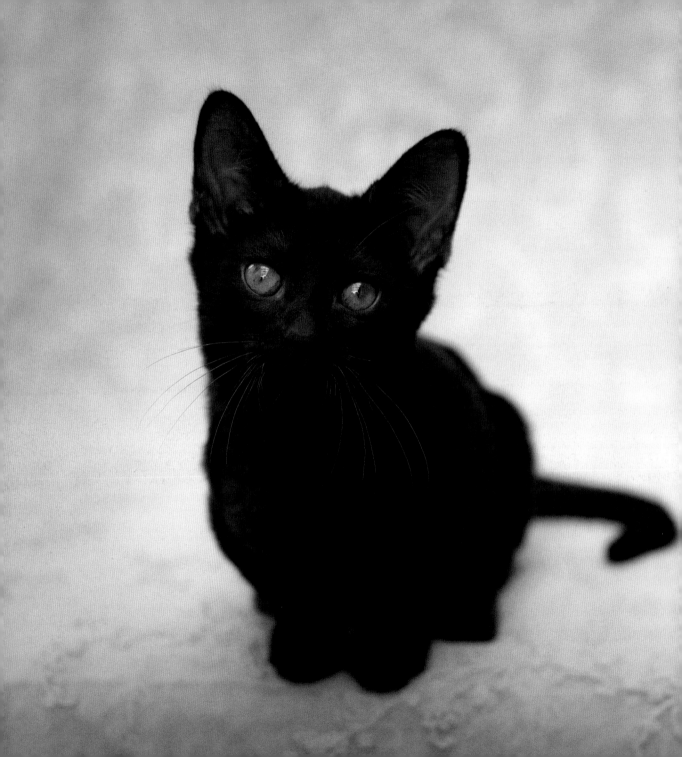

## 90. Munchkin Chocolate

The startling and controversial Munchkin, though small in stature, has a large following and an even larger array of affectionate nicknames including "Dachshund," "Minikat," and "Ferret Cat." The official name, Munchkin, comes from the famous movie *The Wizard of Oz*. The result of a spontaneous natural mutation, the cat is believed to have been discovered first in Britain during the 1930s. However it was not until 1983 in the United States that the Munchkin became established after a short-legged stray cat, later named "Blackberry," became the foundation stock of the modern breed. The diminutive stature is owed to a genetic mutation similar to the gene present in Dachshunds and Corgis. Considered to be extremely healthy, the breed has been accepted by the TICA. Sweet natured and sociable, the charming Munchkin never seems to grow out of its kittenlike playfulness and, as such, has been coined the "Peter Pan" cat.

*Appearance: The Munchkin, with its signature short legs—the front legs being no more than three inches in height—is the founding dwarf breed of the cat world. The medium length and compact body can appear in both shorthair and longhair forms.*

*Color: The Munchkin comes in numerous color and pattern combinations.*

**91. Tibetan**  Red Bicolor

Round and robust, the Tibetan is a modern
feline still currently being developed from the
New Zealand Clippercat. Like its forebear, the
Tibetan is a polydactyl—it carries an unusual gene
that allows it to have extra toes. Typically the front
paws of a cat will have five claws, and the back paws
four, however, the Tibetan can have as many as seven
toes on both the front and back paws. Though not
common, the polydactyl gene has been present for
many centuries. Cats with extra toes were known to
have lived in parts of Britain 200 years ago.

*Appearance: With an overall appearance of round-
ness, the solid and muscular Tibetan is a medium-
sized cat with remarkably large feet big enough to
accommodate the extra toes.*

*Color: The Tibetan can come in an array of colors
and patterns.*

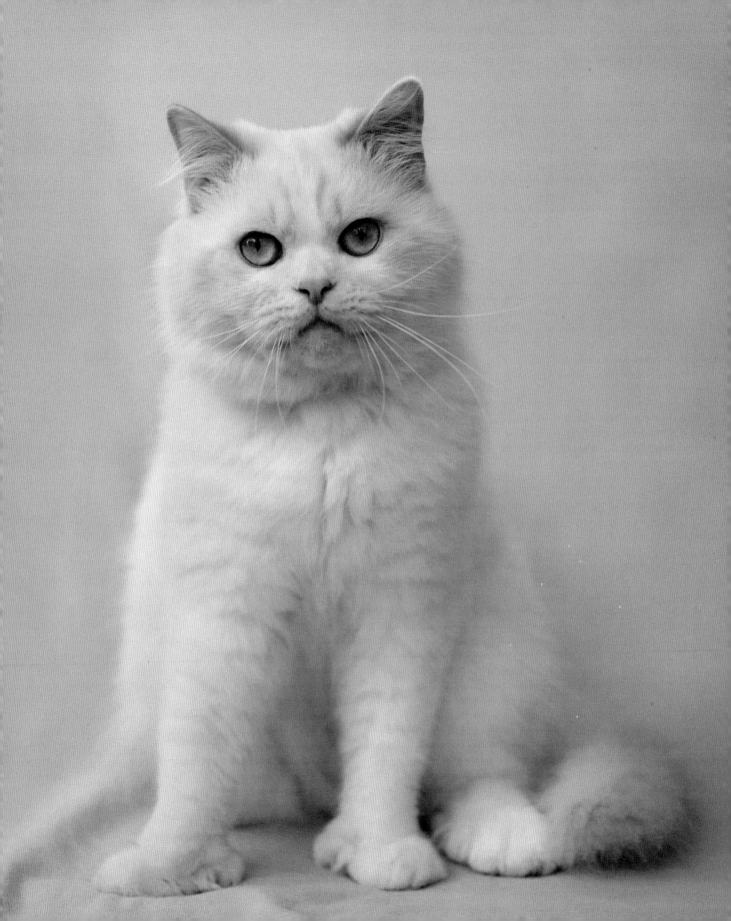

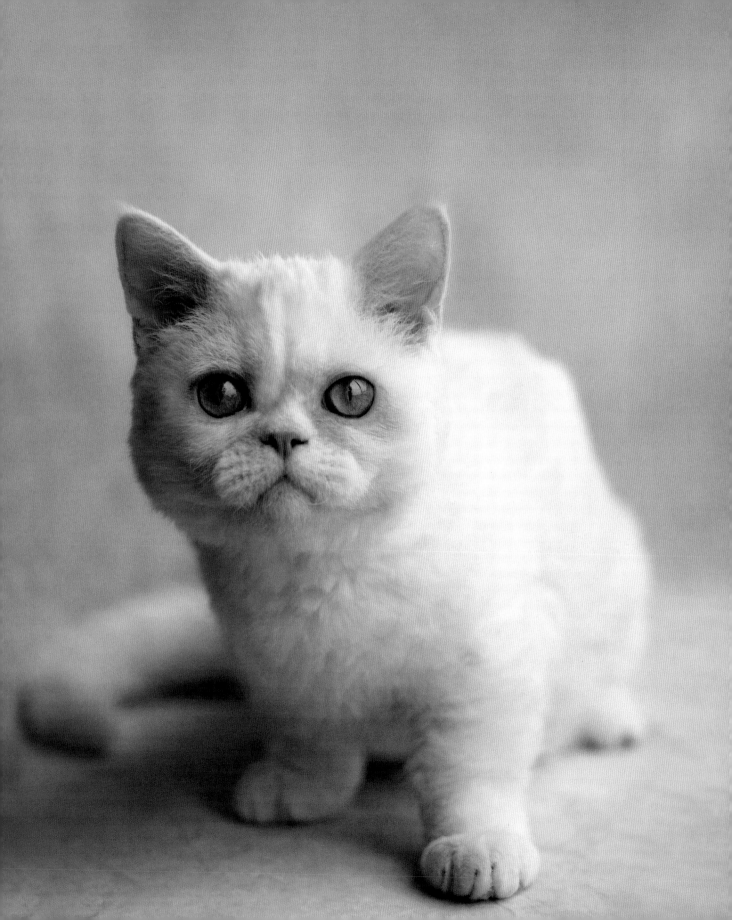

## 92. Lambkin  White

The cute and affectionate Lambkin, whose name means "very young lamb" and who is nicknamed the "cat in a lamb's suit," is a modern dwarf hybrid. The Lambkin was created by crossing the original founding dwarf breed, the Munchkin, to a Selkirk Rex, producing a small cat with a soft, plush curly coat similar to a lamb's. As both founding breeds are naturally occurring mutations, the dominant gene mutation is passed down to the offspring. The founding stock of the Lambkin combines two sweet-natured and sociable breeds. Both are playful and active, and thrive on human and animal companionship alike, making the Lambkin not only incredibly cute, having inherited the signature characteristics of the two breeds, but in addition a lively and loving pet.

*Appearance: The unusual-looking Lambkin combines the small stature of the Munchkin—short stocky legs, a moderate-sized body, and neck with a round head and large eyes—with the curly coat of the Selkirk Rex.*

*Color: The Lambkin appears in all colors and patterns.*

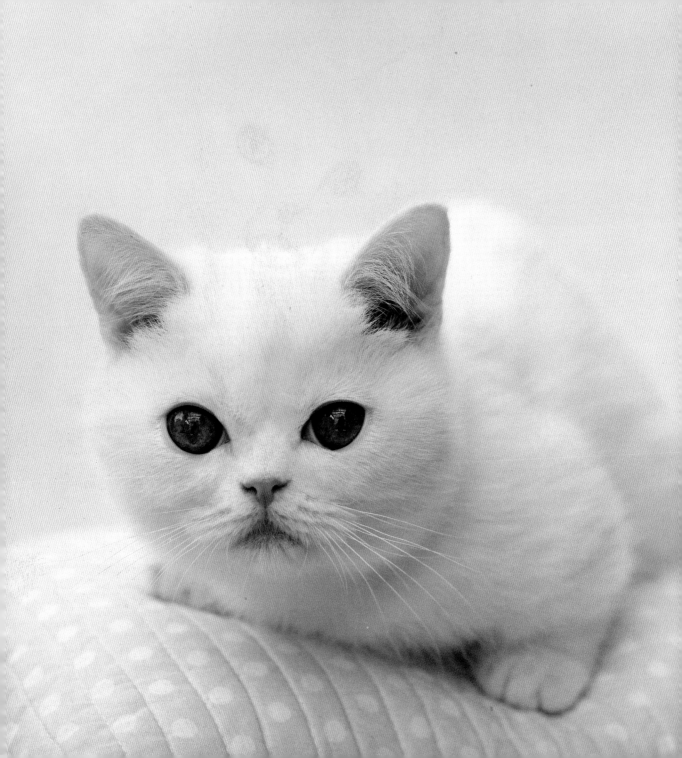

### 93. Napoleon  White

The sweet and composed Napoleon is a modern American hybrid and a member of the dwarf group. The history of the cat begins in 1996 when breeder Joe Smith initiated the calculated crossing of cats from the Persian group (including Persians, Himalayans, and Exotic Shorthairs) with the Munchkin. The outcome, called Napoleon (no doubt due to its small stature), has acquired from its Persian ancestors a robust and muscular body, a round face and eyes, and its dense and colorful coat. The short legs of the Munchkin, from a naturally occurring spontaneous mutation, have also been passed on. Sweet natured and even tempered, the Napoleon is quickly growing in popularity. A loving and playful cat, it is a competent runner, jumper, and climber, while equally it enjoys quiet lap time.

*Appearance: Part of the dwarf family, the Napoleon is a strong and sturdy breed with a medium-length well-rounded body on short yet powerful legs. The head is round with full cheeks and large round eyes. The Napoleon can appear in both shorthair and longhair forms, the long being abundant, while the short appears plush and longer than most shorthairs.*

*Color: The Napoleon appears in all colors and patterns.*

## 94. Skookum  White, Cream, and White

The Skookum, affectionately referred to as the "Shirley Temple Cat," is a modern hybrid breed developed by Roy Galusha in the United States during the 1990s. Galusha sought a new breed that presented the very small stature of the Munchkin with an added curly coat. He successfully produced the contemporary Skookum by crossing the diminutive Munchkin with the curly-coated LaPerm. The Skookum has inherited the temperaments of both parent breeds. The playful, friendly, and sweet nature of the Munchkin is enhanced by the devotion and attentiveness of the LaPerm to produce an incredibly loyal and affectionate breed. The Skookum loves to jump and climb, and will retain its high-spirited kitten qualities into adulthood, charming all those that meet it.

*Appearance: The Skookum is similar in appearance to its founding breed, the short-legged Munchkin. However, within each litter both short- and long-legged kittens (or standard and nonstandard) can appear, with the long-legged variant retaining all other features of the Skookum except its short stature. A moderate-sized body and neck supports a round head with large eyes and very prominent curled whiskers and eyebrows. The coat can be either short-haired or long-haired with a curl or wave, and is soft to the touch.*

*Color: The Skookum appears in all colors and patterns.*

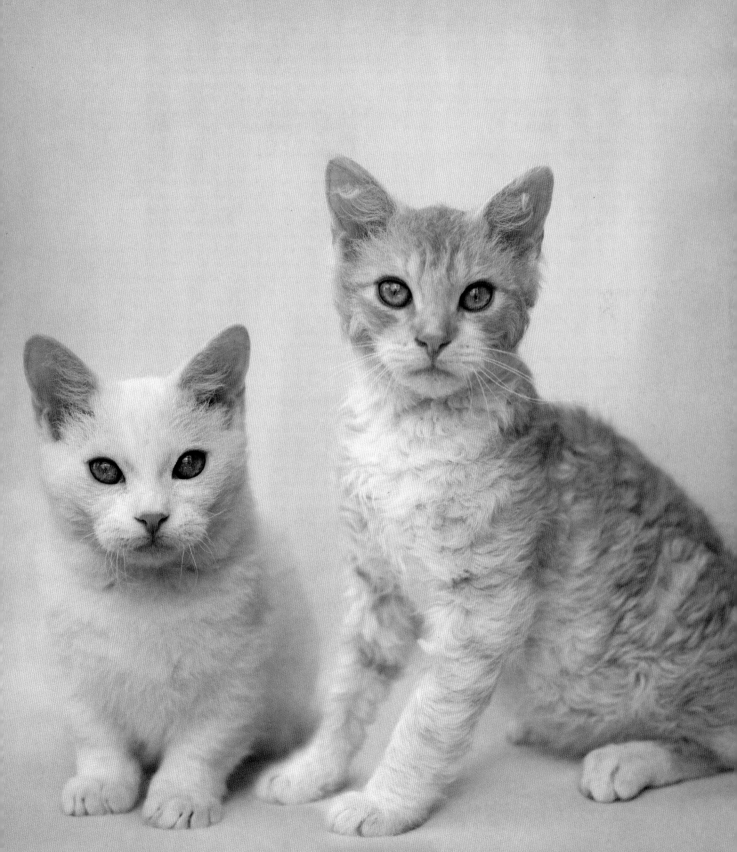

## 95. Classic Tabby  Brown

The Classic Tabby is a nonpedigree cat and notably the most common household pet worldwide. Its large population is no doubt aided by the fact that the Classic Tabby carries the two most dominant genes of the cat world. The first being the tabby gene and the second being the shorthaired gene. The tabby pattern, an effective form of camouflage, has been retained from its ancestor—the predecessor of all domestic felines—the African wildcat. And like its ancestor, the Tabby has remained a talented hunter; it is immensely self-sufficient and today still a useful and active participant in and around the home. Independent though it may be, the Tabby is at heart a cat like any other and will never turn down a welcoming lap or give up the best seat in front of a warm fire.

*Appearance: The Classic Tabby has a distinctive coat of swirling broad stripes that usually form a bull's-eye or oyster pattern on the torso. Other tabby patterns are ticked, mackerel, and spotted; and like the classic, the mackerel and spotted appear with the signature "M" mark on the forehead.*

*Color: The Brown Classic Tabby is the most popular color of nonpedigree Tabby cat. A light brown ground color accentuates the black markings while the coat is complemented by black eyeliner and nose trim.*

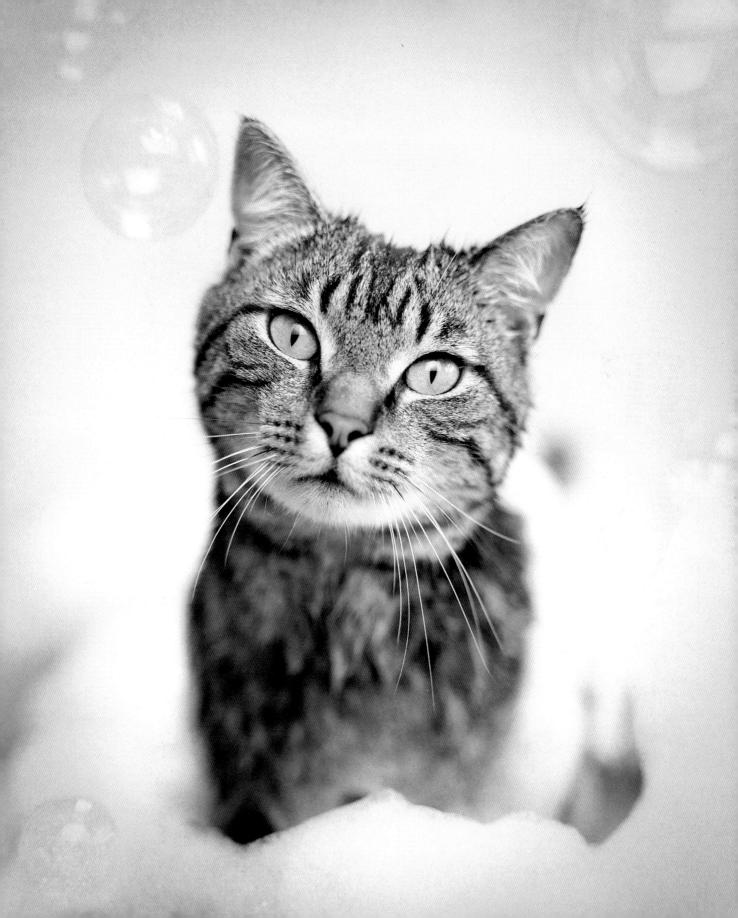

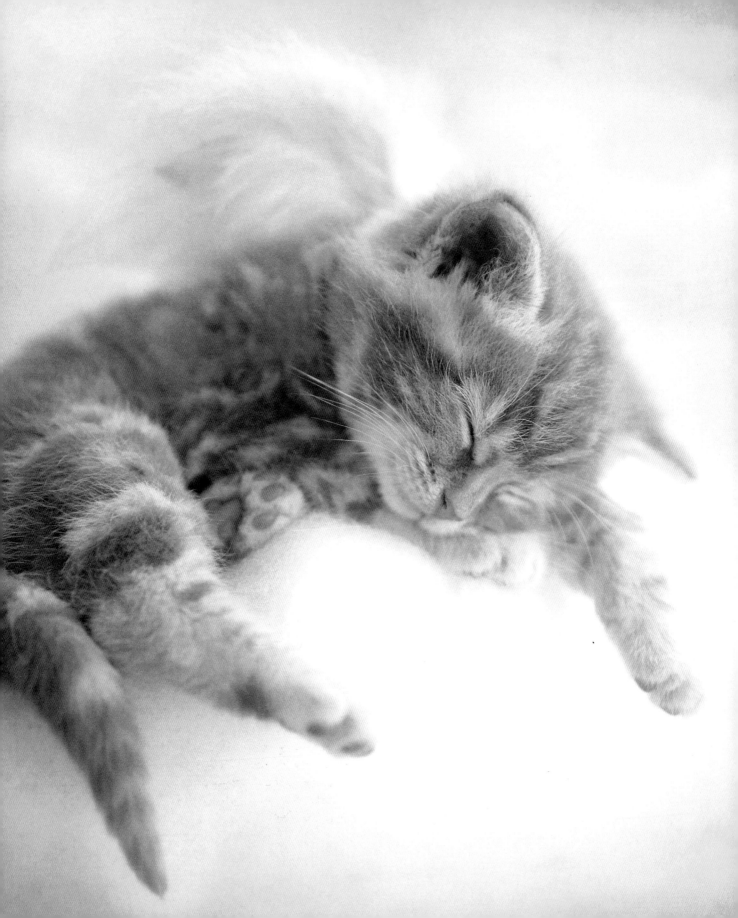

### 96. Classic Tabby  Ginger

Commonly nicknamed "marmalade," the color ginger goes by many names. Geneticists historically called it "yellow"; today it is called "orange," while cat breeders call it "red." No matter the name, the warm tone that the ginger gene produces (due to its inability to show any black or brown pigment) is without doubt a delightful sight, and mixed with the tabby pattern is rather hypnotic, producing a flamelike effect.

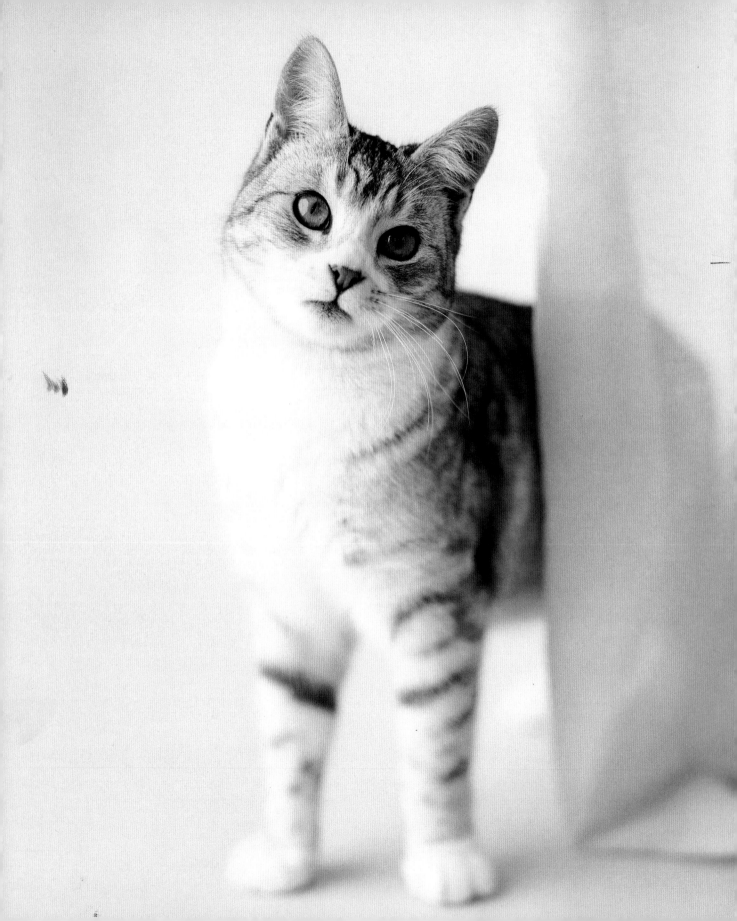

Time spent with cats is never wasted.

COLETTE

### 97. Classic Tabby Silver

Rich in color and contrast, the delightful Silver Tabby
is a regal-looking cat. Its dark tabby markings appear
to almost jump out from the pale silver ground color,
while the brick-red nose and eyes are heavily rimmed
in black.

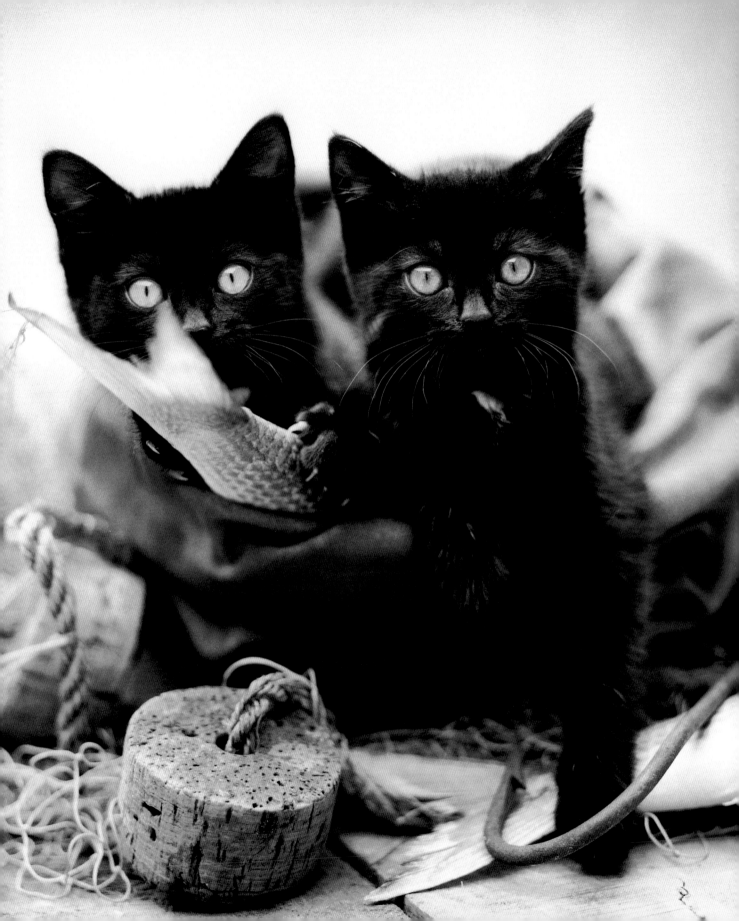

### 98. Domestic Shorthair  Black

Affectionately known as the "Moggie," the Domestic is a nonpedigree cat of either a mixed or unknown type, not belonging to any recognized breed. The Domestic cat, like the Classic Tabby, frequently displays the tabby markings of its African wildcat ancestor. The Domestic has had a very long and adoring relationship with humans; it was originally domesticated for its hunting ability and admired for its beauty, size, and autonomous yet social nature. Today the Domestic is firmly established as a popular house cat: it is widely appreciated for its independent and active nature with a "get-on-with-it" approach to life, as well as its social and affectionate disposition.

*Appearance: Strong and muscular, the Domestic is typically medium-to-large in size and can appear in all lengths of coat from long and full to short and dense.*

*Color: The Domestic appears in a range of colors and patterns with black, black and white, and the tabby pattern being the more recognized variations.*

### 99. Domestic Mediumhair  White

The purity of white throughout history has always
been highly valued and the white-coated cat is no
different, being greatly admired and a favorite on the
show circuit. Even during the late 1800s (though not
as glamorous as the show bench) the White
Domestic was highly sought after as a hunter by
millers, who saw the white coat as an added camou-
flage advantage among the white flour stocks.

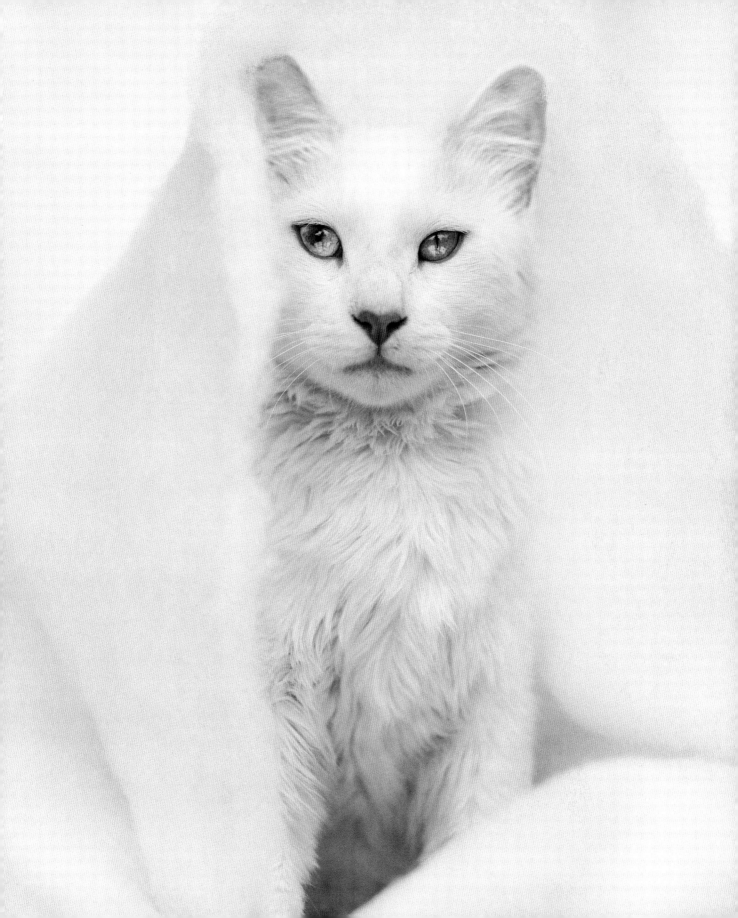

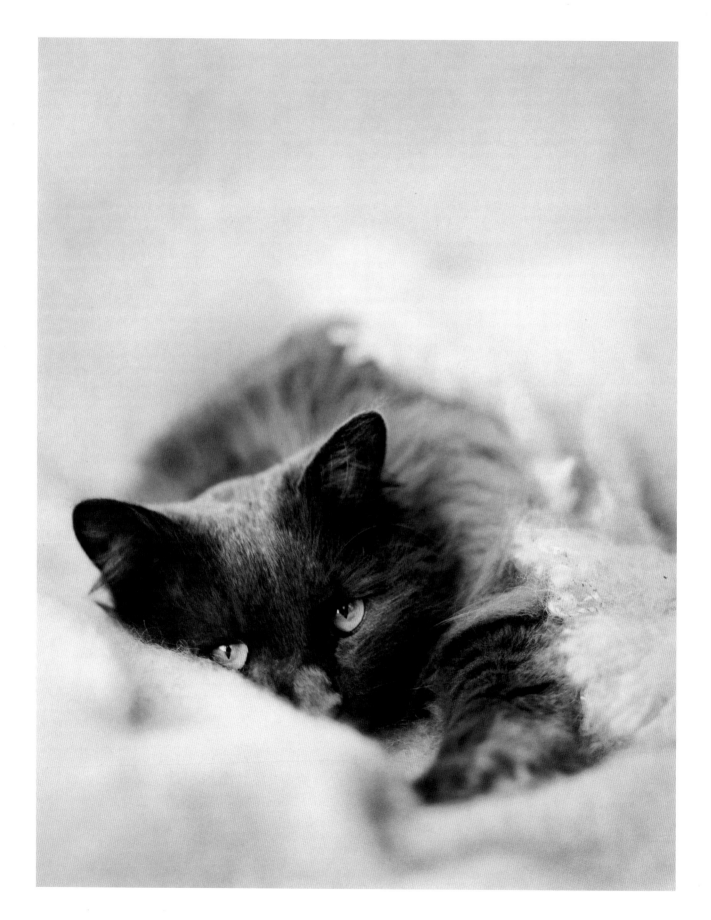

**100. Domestic Longhair** Blue

Considered to be calmer and more reserved than its short-haired cousin, the Domestic Longhair is a popular family cat. Like most nonpedigree cats, the tabby and the bicolor are the most prevalent coat patterns. The Blue Domestic Longhair has an even color of rich slate blue.

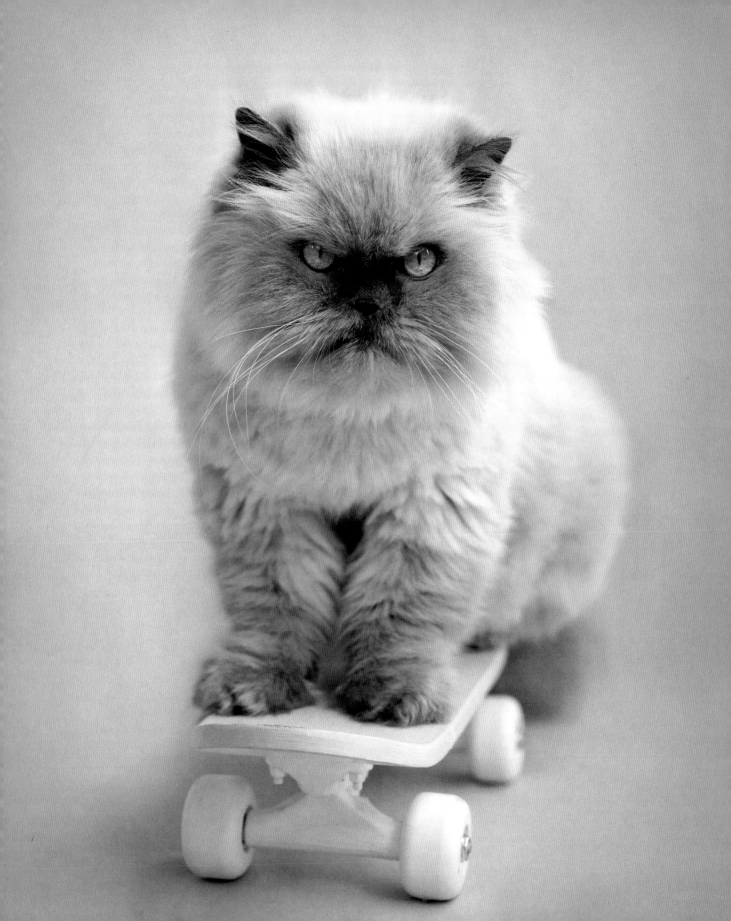

## 101. **Himalayan Persian**  Blue Point

The 101st cat in this book is my own Edmund. Eddie is more like a dog than a cat. He's a Himalayan Persian, a very laid-back breed to start with, but Eddie *defines* laid-back. Other people might call him lazy. I call him a guttersnipe as he loves to lie in the gutter in our street and gossip with everyone who walks past. In fact, when he's naughty (which is very seldom) I threaten him with a move to the country and no neighbors to chat to!

Everyone who meets Eddie falls in love with him. He is comical in appearance with his perpetually grumpy expression, despite not being remotely grumpy by nature. He is very bossy, though, and is the kingpin of the neighborhood cats, keeping them in line.

Eddie is also a grub and has to have a regular haircut and shampoo. I think it might be because he was taken from his mother too early and wasn't taught how to groom himself properly. Either that or it is just his extreme laziness. Eddie and his sister were the only survivors of a large litter. I came across them while photographing cats for the local SPCA. I spied his sister, Hillary, first, a beautiful bundle perched on the reception desk. My heart skipped a beat. The disappointment in discovering the tiny kitten was spoken for was alleviated upon meeting her equally adorable brother. That was it; Eddie went home with me. Given his sister's name, and the Himalayan background, I felt I had no choice but to name him Edmund after our mountaineering legend Sir Edmund Hillary. While showing no sign of the athletic prowess of his namesake, I'm sure Eddie thinks "Sir" would befit him admirably.

# Index

# Worldwide Cat Associations

Any cat lover can be a called a "cat fancier." However, there are a number of organizations, associations, and councils devoted to promoting and showing pedigree breeds. Below is a list of the breeds appearing in this book and the various organizations that recognize them.

CFA    Cat Fanciers' Association (USA)
NZCF    New Zealand Cat Fancy
GCCF    Governing Council of the Cat Fancy (UK)
TICA    The International Cat Association
CCA    Canadian Cat Association
ACF    Australian Cat Federation
TSACC    The Southern African Cat Council
TDCA    The Designer Cat Association
FIFe    Fédération International Féline
CATZ    NZ National Registry for Cats Inc
ACFA    American Cat Fanciers Association

## Shorthair

1    Abyssinian—CFA; NZCF; GCCF; TICA; CCA; ACF; TSACC; FIFe; CATZ; ACFA
2–4    Bengal—NZCF; GCCF; TICA; CCA; ACF; TSACC; TDCA; FIFe; ACFA
5–12    British Shorthair—CFA; NZCF; GCCF; TICA; CCA; ACF; FIFe; CATZ; ACFA
13–17    Burmese—CFA; NZCF; GCCF; TICA; CCA; ACF; TSACC; FIFe; CATZ; ACFA
18    Classicat—NZCF
19–20    Cornish Rex—CFA; NZCF; GCCF; TICA; CCA; ACF; TSACC; TDCA; FIFe; CATZ; ACFA
21–22    Devon Rex—CFA; NZCF; GCCF; TICA; CCA; ACF; TSACC; TDCA; FIFe; CATZ; ACFA
23    Egyptian Mau—NZCF; GCCF; TICA; CCA; ACF; FIFe; CATZ; ACFA
24–26    Exotic Shorthair—CFA; NZCF; GCCF; TICA; CCA; ACF; TSACC; FIFe; CATZ; ACFA
27    Japanese Bobtail—CFA; NZCF; TICA; CCA; ACF; TSACC; TDCA; FIFe; CATZ; ACFA
28    Korat—CFA; GCCF; TICA; CCA; ACF; TSACC; FIFe; CATZ; ACFA
29–30    Mandalay—NZCF; CATZ
31    Manx—CFA; NZCF; TICA; CCA; ACF; TSACC; TDCA; FIFe; CATZ; ACFA
32–34    Ocicat—CFA; NZCF; GCCF; TICA; CCA; ACF; FIFe; CATZ; ACFA
35    Russian Blue—CFA; NZCF; GCCF; TICA; CCA; ACF; TSACC; FIFe; CATZ; ACFA
36    Scottish Fold—CFA; NZCF; TICA; CCA; ACF; TSACC; TDCA; CATZ; ACFA
37–39    Selkirk Rex—CFA; NZCF; GCCF; TICA; CCA; ACF; TDCA; CATZ; ACFA
40    Singapura—CFA; NZCF; GCCF; TICA; CCA; ACF; TSACC; ACFA
41    Snowshoe—GCCF; TICA; FIFe; CATZ; ACFA
42    Sphynx—CFA; NZCF; GCCF; TICA; CCA; ACF; TSACC; TDCA; FIFe; CATZ; ACFA
43    Temple Cat—CATZ
44    Tonkinese—CFA; NZCF; GCCF; TICA; CCA; ACF; TSACC; CATZ; ACFA

## Semilonghair

45–46    Birman—CFA; NZCF; GCCF; TICA; CCA; ACF; TSACC; CATZ; ACFA
47–48    Cymric—NZCF; TICA; CCA; ACF; TSACC; TDCA; FIFe; CATZ

49–50    Highland Fold—CFA (under Scottish Fold Longhair); NZCF (Scottish Fold Longhair); TICA; CCA (Scottish Fold Longhair); ACF (Scottish Fold Longhair); TSACC; CATZ; ACFA
51    Highland Variant—CATZ
52    Japanese Bobtail Longhair—CFA; NZCF; TICA; ACF; ACFA
53–55    LaPerm—CFA; NZCF; GCCF; TICA; TSACC; TDCA; CATZ
56–60    Maine Coon—CFA; NZCF; GCCF; TICA; CCA; ACF; TSACC; FIFe; CATZ; ACFA
61    Norwegian Forest—CFA; NZCF; GCCF; TICA; CCA; ACF; TSACC FIFe; CATZ; ACFA
62–64    Ragdoll—CFA; NZCF; GCCF; TICA; CCA; ACF; TSACC; FIFe; CATZ; ACFA
65–67    Somali—CFA; NZCF; GCCF; TICA; CCA; ACF; TSACC; CATZ; ACFA
68    Turkish Van—CFA; NZCF; TICA; ACF; TSACC; FIFe; CATZ; ACFA

## Longhair

69    Chinchilla Persian—CFA (under Persian); NZCF; GCCF; TICA (Persian); CCA
70–71, 73–75    Persian—CFA; NZCF; GCCF; TICA; CCA; ACF; TSACC; FIFe; CATZ; ACFA
72,101    Himalayan Persian (Colourpoint)—CFA (Colourpoint); NZCF (Colourpoint); GCCF; TICA; CCA; ACF (Colourpoint); ACFA

## Asian

76    Asian Shorthair—GCCF
77    Bombay—CFA; GCCF; TICA; CCA; ACF; TSACC; ACFA
78    Burmilla—NZCF; GCCF; CCA; ACF; TSACC; FIFe; CATZ
79–82    Tiffanie—GCCF; TSACC

## Oriental

83–84    Balinese—CFA; NZCF; GCCF; TICA; CCA; ACF; TSACC; FIFe; CATZ
85    Havana/NZ—CFA (called Havana Brown); GCCF; TICA; CCA; ACFA
86    Javanese—CFA; NZCF; ACF; CATZ
87    Oriental Shorthair—CFA; NZCF; GCCF; TICA; CCA; ACF; ACFA
88    Oriental—CFA; NZCF; GCCF; TICA; CCA; ACF; TSACC; FIFe; CATZ; ACFA
89    Siamese—CFA; NZCF; GCCF; TICA; CCA; ACF; TSACC; FIFe; CATZ; ACFA

## Miscellaneous

90    Munchkin—TICA; TDCA; CATZ
91    Tibetan—breed still being developed
92    Lambkin—TDCA
93    Napoleon—TDCA; CATZ
94    Skookum—TDCA
95–97    Classic Tabby (nonpedigree)—TICA (most registries hold a Household—nonpedigree—class for showing)
98    Domestic Shorthair (nonpedigree)—TICA; TSACC (most registries hold a Household—nonpedigree—class for showing)
99    Domestic Mediumhair (nonpedigree)—TICA; TSACC (most registries hold a Household—nonpedigree—class for showing)
100    Domestic Longhair (nonpedigree)—TICA; TSACC (most registries hold a Household—nonpedigree—class for showing)

ISBN-13: 978-0-7407-7964-0
ISBN-10: 0-7407-7964-8
Library of Congress Control Number: 2008935763

This edition produced and originated by PQ Blackwell Limited,
116 Symonds Street, Auckland, New Zealand
www.pqblackwell.com

This edition published by Andrews McMeel Publishing, LLC,
1130 Walnut Street, Kansas City, Missouri 64106
www.andrewsmcmeel.com

Text and concept copyright © 2009 PQ Blackwell Limited.

Printed by Midas Printing International Limited, China

The following images, including front cover image are copyright © 2009
Rachael Hale Trust:
Page 10 (Abyssinian), 102 (Birman), 34 (Burmese), 37 (Burmese),
38 (Burmese), 41 (Burmese), 170 (Burmilla), 44 (Classicat), 212 (Classic
Tabby), 50 (Devon Rex), 186 (Havana), 109 (Highland Fold),
110 (Highland Fold), 220 (Himalayan Persian), 62 (Japanese Bobtail),
115 (Japanese Bobtail), 202 (Lambkin), 116 (LaPerm), 119 (LaPerm),
120 (LaPerm), 70 (Manx), 198 (Munchkin), 204 (Napoleon), 72 (Ocicat),
74 (Ocicat), 77 (Ocicat), 82 (Selkirk Rex), 84 (Selkirk Rex), 86 (Selkirk Rex),
89 (Singapura), 207 (Skookum), 90 (Snowshoe), 142 (Somali), 145 (Somali),
201 (Tibetan), 178 (Tiffanie), 147 (Turkish Van).

All other images, including back cover image, are copyright
© 2009 Dissero Brands Limited, New Zealand. All worldwide rights reserved.
www.rachaelhale.com
Page 166 (Asian Shorthair), 182 (Balinese), 185 (Balinese), 13 (Bengal),
15 (Bengal), 17 (Bengal), 101 (Birman), 168 (Bombay), 19 (British Shorthair),
20 (British Shorthair), 22 (British Shorthair), 25 (British Shorthair), 27 (British
Shorthair), 29 (British Shorthair), 30 (British Shorthair), 33 (British Shorthair),
42 (Burmese), 151 (Chinchilla Persian), 209 (Classic Tabby), 210 (Classic
Tabby), 46 (Cornish Rex), 49 (Cornish Rex), 105 (Cymric), 106 (Cymric),
53 (Devon Rex), 218 (Domestic Longhair), 217 (Domestic Mediumhair),
214 (Domestic Shorthair), 54 (Egyptian Mau), 56 (Exotic Shorthair),
59 (Exotic Shorthair), 61 (Exotic Shorthair), 112 (Highland Variant),
156 (Himalayan Persian), 189 (Javanese), 64 (Korat), 123 (Maine Coon),
125 (Maine Coon), 126 (Maine Coon), 129 (Maine Coon), 130 (Maine Coon),
67 (Mandalay), 68 (Mandalay), 133 (Norwegian Forest), 190 (Oriental),
193 (Oriental), 153 (Persian), 154 (Persian), 159 (Persian), 161 (Persian),
162 (Persian), 135 (Ragdoll), 136 (Ragdoll), 139 (Ragdoll), 79 (Russian Blue),
81 (Scottish Fold), 194 (Siamese), 141 (Somali), 92 (Sphynx), 94 (Temple
Cat), 172 (Tiffanie), 175 (Tiffanie), 177 (Tiffanie), 97 (Tonkinese).

The publisher is grateful for literary permissions to reproduce those items
below subject to copyright. Every effort has been made to trace the
copyright holders and the publisher apologizes for any unintentional
omission. We would be pleased to hear from any not acknowledged here
and undertake to make all reasonable efforts to include the appropriate
acknowledgment in any subsequent editions.

Quotation on page 76 from *The Cat Who Came For Christmas* by
Cleveland Amory; used with permission of Little, Brown and Company.
Quotation on page 87 reprinted with permission of Penny Moser.
Quotation on page 128 reprinted with permission of Karen Brademeyer.